FLOWER
DESIGNS *and* MOTIFS
CD-ROM and Book

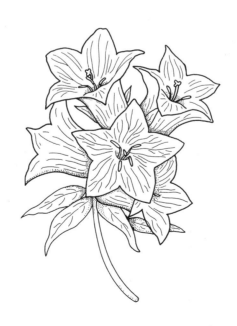

DOVER PUBLICATIONS, INC.
MINEOLA, NEW YORK

Planet Friendly Publishing
✔ Made in the United States
✔ Printed on Recycled Paper
Learn more at www.greenedition.org

At Dover Publications we're committed to producing books in an earth-friendly manner and to helping our customers make greener choices.

Manufacturing books in the United States ensures compliance with strict environmental laws and eliminates the need for international freight shipping, a major contributor to global air pollution.

And printing on recycled paper helps minimize our consumption of trees, water and fossil fuels. The text of *Flower Designs and Motifs CD-ROM and Book* was printed on paper made with 30% post-consumer waste, and the cover was printed on paper made with 10% post-consumer waste. According to Environmental Defense's Paper Calculator, by using this innovative paper instead of conventional papers, we achieved the following environmental benefits:

Trees Saved: 8 • Air Emissions Eliminated: 616 pounds
Water Saved: 2,493 gallons • Solid Waste Eliminated: 323 pounds

For more information on our environmental practices, please visit us online at www.doverpublications.com/green

The CD-ROM inside this book contains all of the images. There is no installation necessary. Just insert the CD into your computer and call the images into your favorite software (refer to the documentation with your software for further instructions). Each image has been scanned at 600 dpi and saved in six different formats—BMP, EPS, GIF, JPEG, PICT, and TIFF. The JPEG and GIF files—the most popular graphics file types used on the Web—are Internet ready.

The "Images" folder on the CD contains a number of different folders. All of the TIFF images have been placed in one folder, as have all of the PICT, all of the EPS, etc. The images in each of these folders are identical except for file format. Every image has a unique file name in the following format: xxx.xxx. The first 3 or 4 characters of the file name, before the period, correspond to the number printed with the image in the book. The last 3 characters of the file name, after the period, refer to the file format. So, 001.TIF would be the first file in the TIFF folder.

Also included on the CD-ROM is Dover Design Manager, a simple graphics editing program for Windows that will allow you to view, print, crop, and rotate the images.

For technical support, contact:
Telephone: 1 (617) 249-0245
Fax: 1 (617) 249-0245
Email: dover@artimaging.com
Internet: **http://www.dovertechsupport.com**
The fastest way to receive technical support is via email or the Internet.

Copyright

Copyright © 1984, 1994, 2005 by Dover Publications, Inc.
Electronic images copyright © 2005 by Dover Publications, Inc.
All rights reserved.

Bibliographical Note

Flower Designs and Motifs CD-ROM and Book, first published in 2005, is a new selection of designs from *Floral Designs and Motifs for Artists, Needleworkers and Craftspeople,* originally published by Dover Publications, Inc., in 1984, and *Flower Designs,* originally published by Dover Publications, Inc., in 1994.

Dover Electronic Clip Art®

These images belong to the Dover Electronic Clip Art Series. You may use them for graphics and crafts applications, free and without special permission, provided that you include no more than ten in the same publication or project. For permission for additional use, please write to Permissions Department, Dover Publications, Inc., 31 East 2nd Street, Mineola, New York 11501, or email us at rights@doverpublications.com

However, republication or reproduction of any illustration by any other graphic service, whether it be in a book, electronic, or in any other design resource, is strictly prohibited.

International Standard Book Number
ISBN-13: 978-0-486-99665-3
ISBN-10: 0-486-99665-4

Manufactured in the United States of America
Dover Publications, Inc., 31 East 2nd Street, Mineola, N.Y. 11501

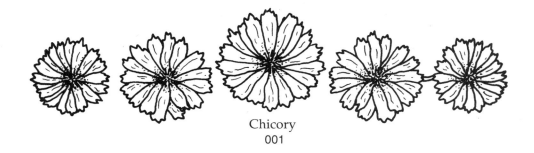

Chicory
001

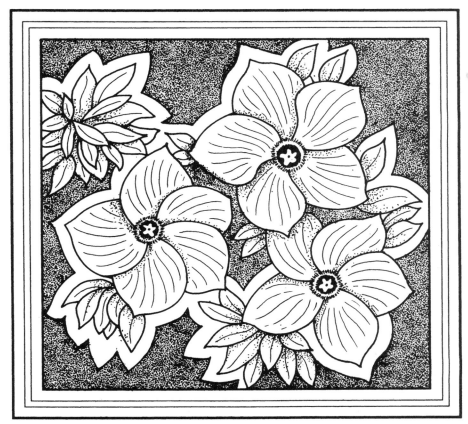

Oxalis
002

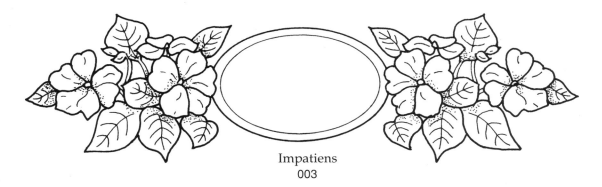

Impatiens
003

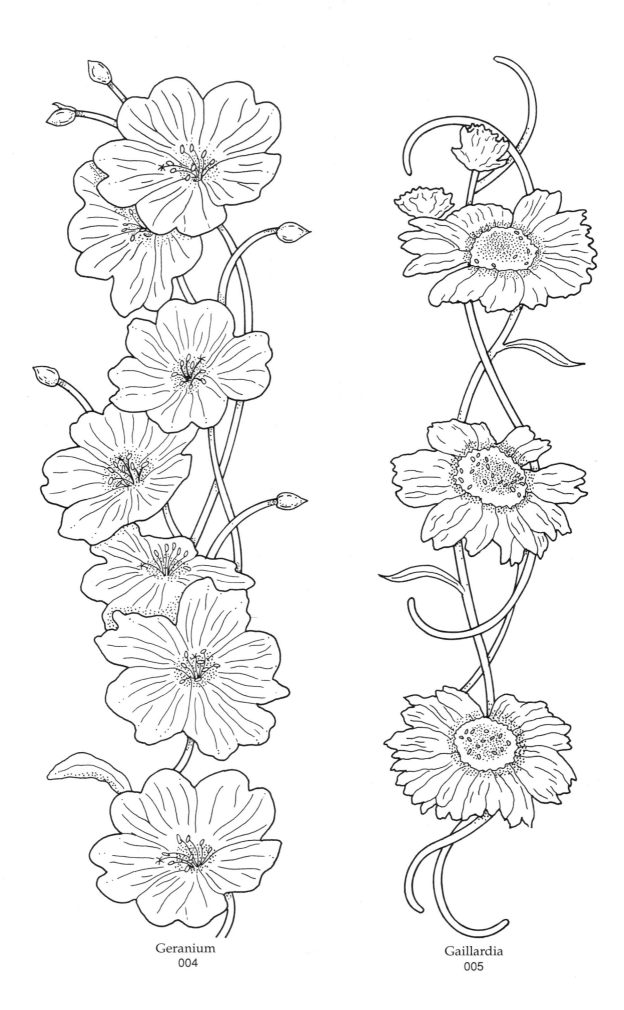

Geranium
004

Gaillardia
005

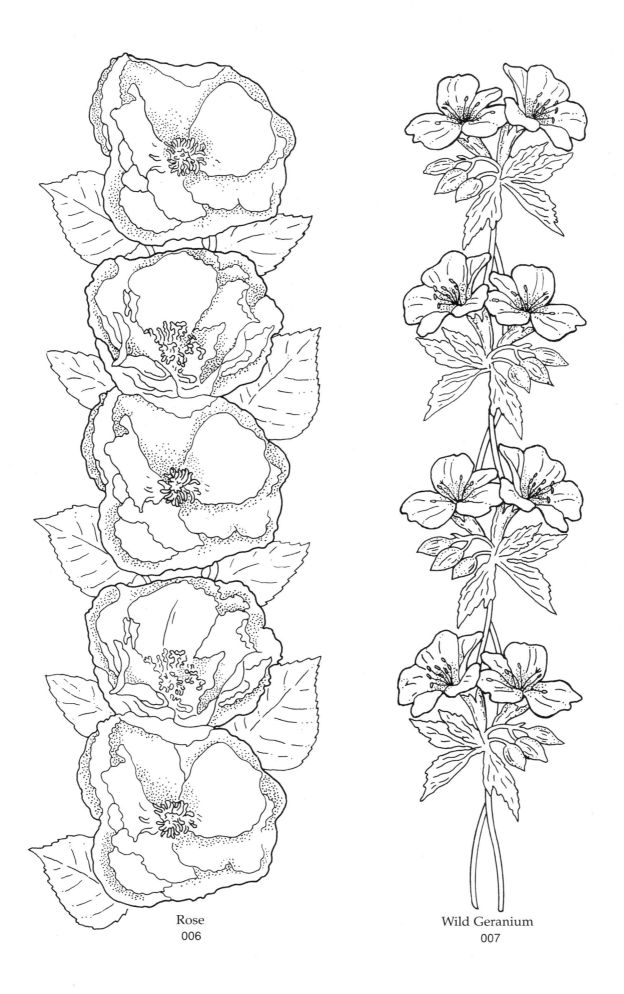

Rose
006

Wild Geranium
007

3

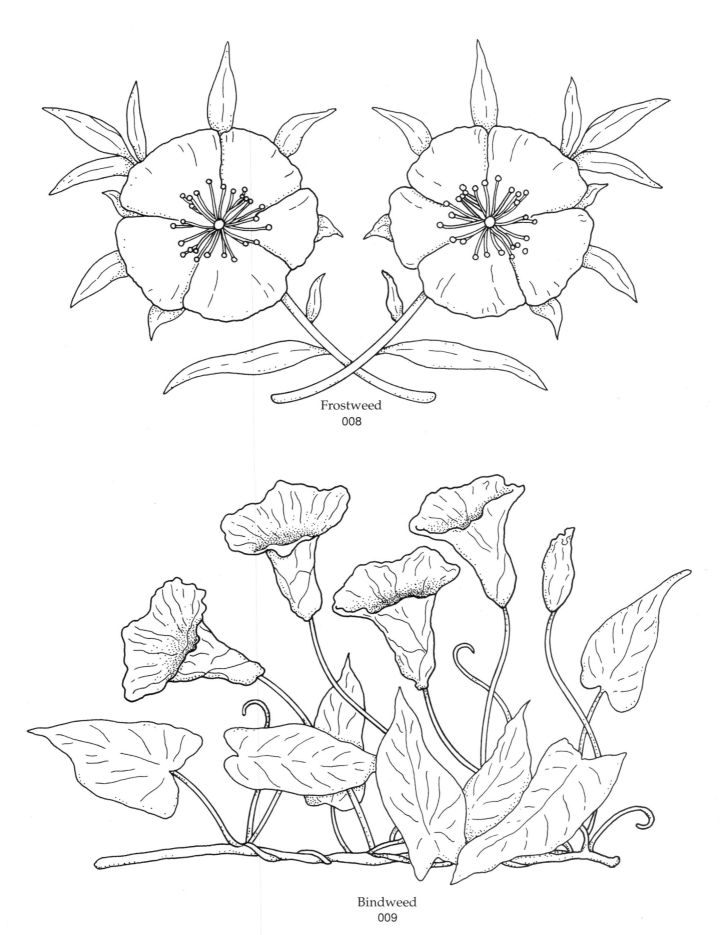

Frostweed
008

Bindweed
009

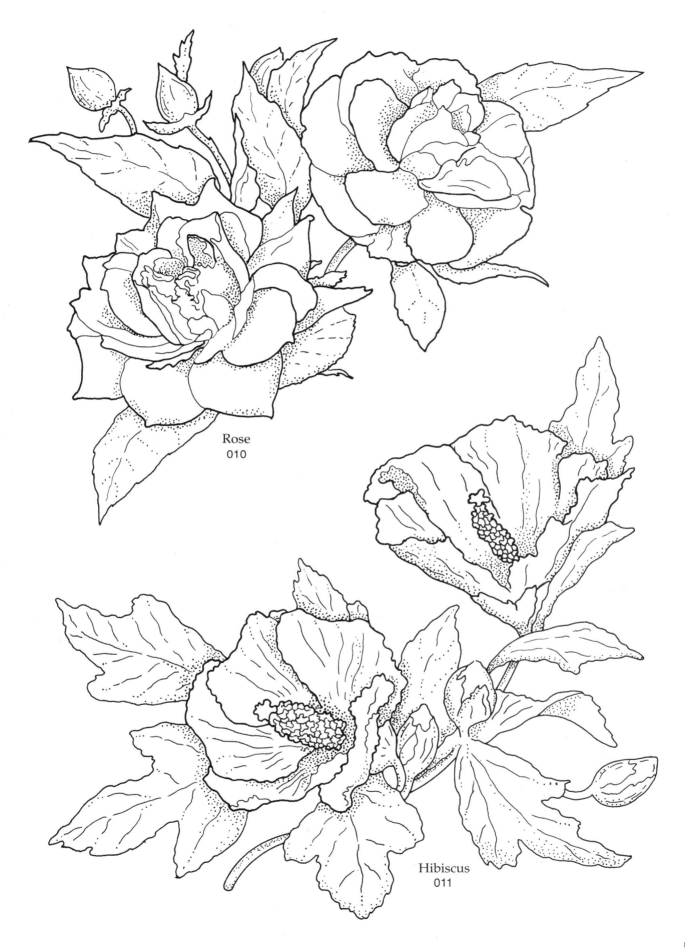

Rose
010

Hibiscus
011

5

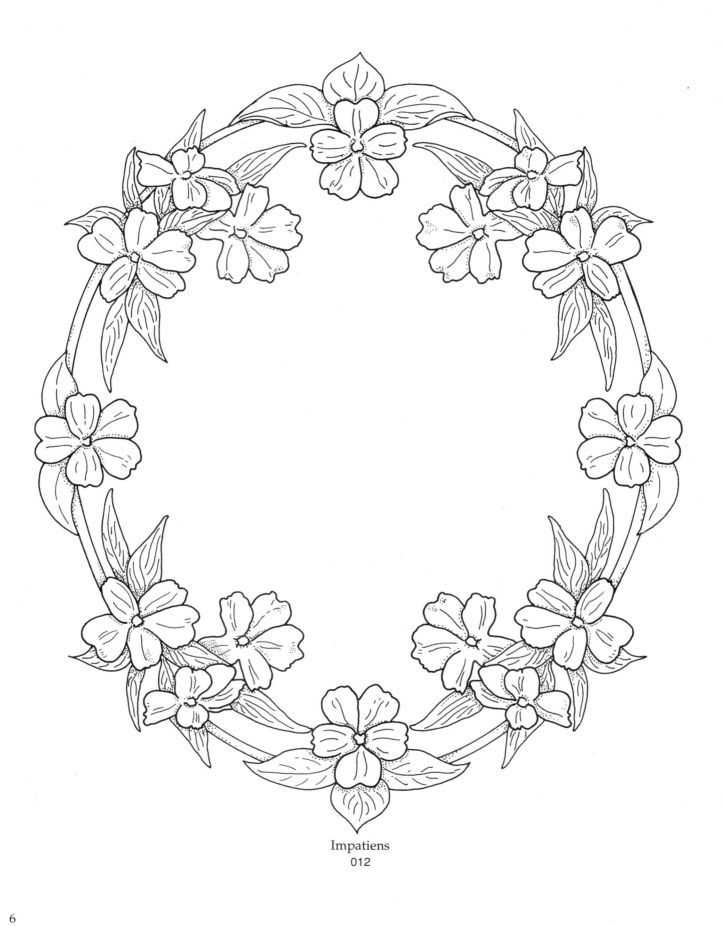

Impatiens
012

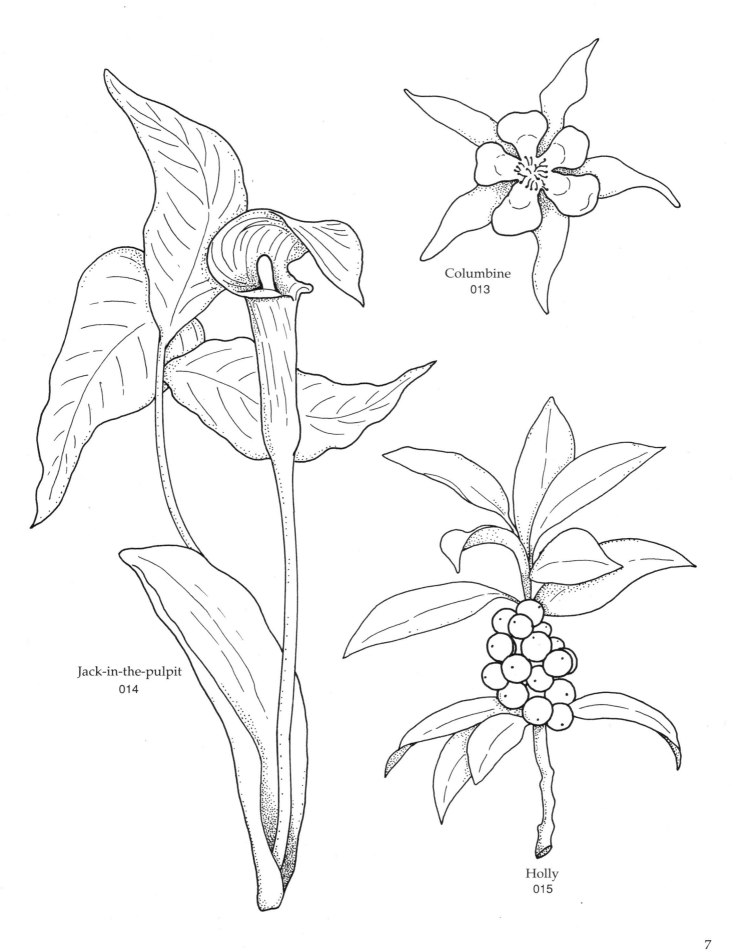

Columbine
013

Jack-in-the-pulpit
014

Holly
015

7

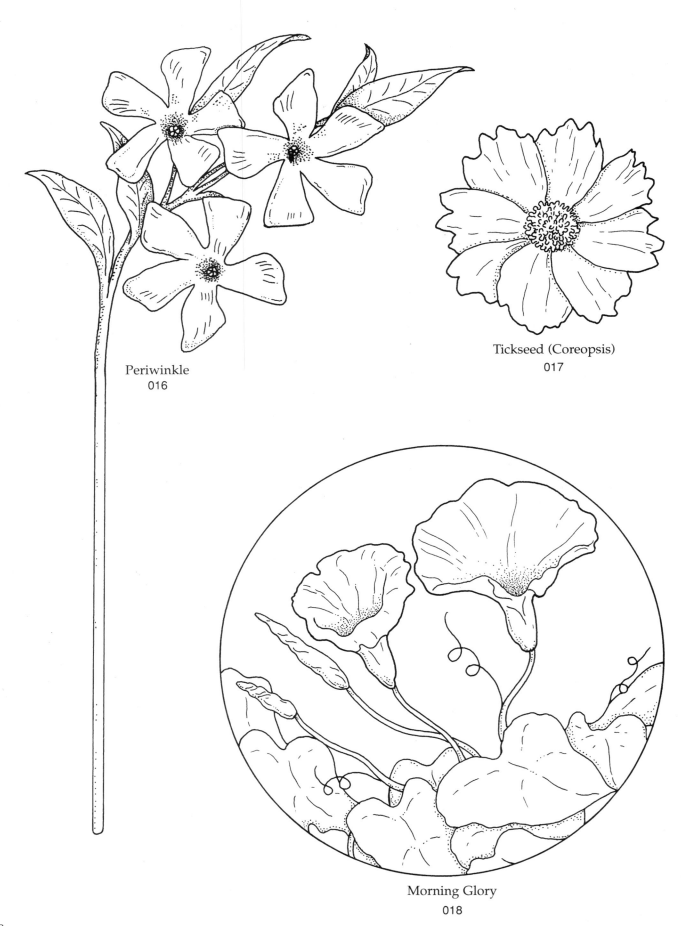

Periwinkle
016

Tickseed (Coreopsis)
017

Morning Glory
018

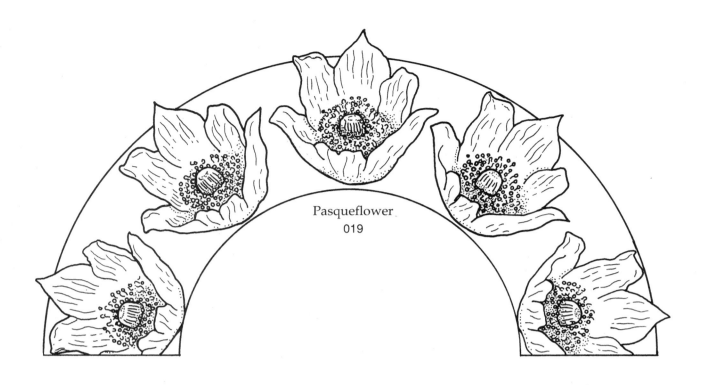

Pasqueflower
019

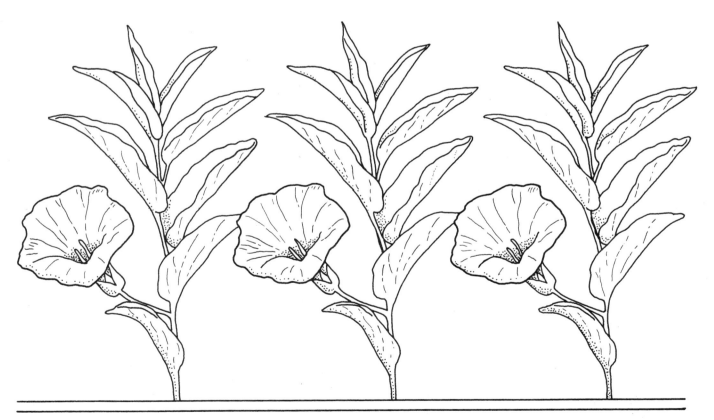

Low Bindweed
020

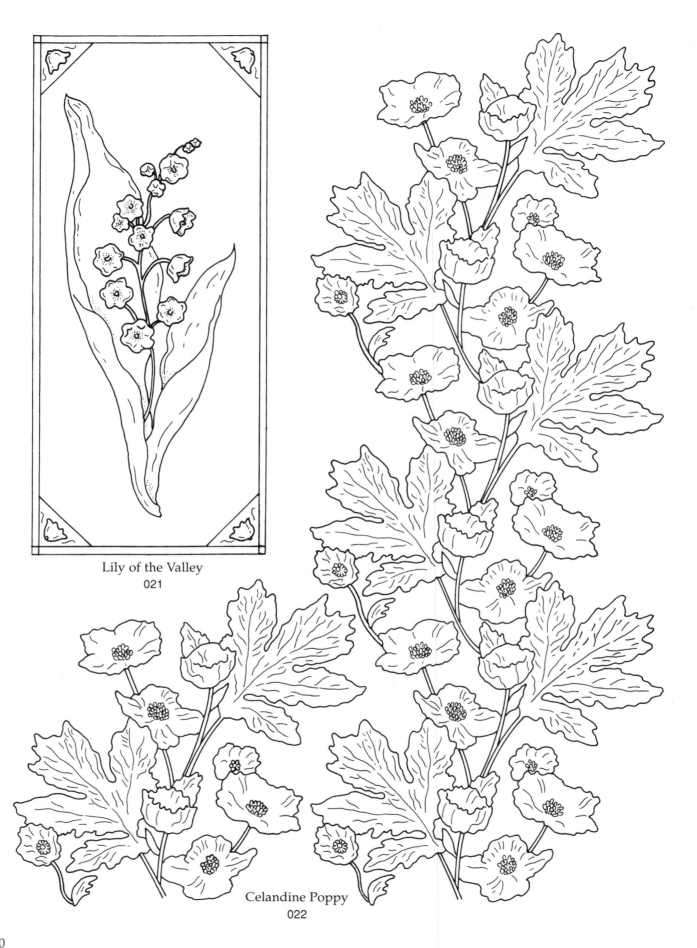

Lily of the Valley
021

Celandine Poppy
022

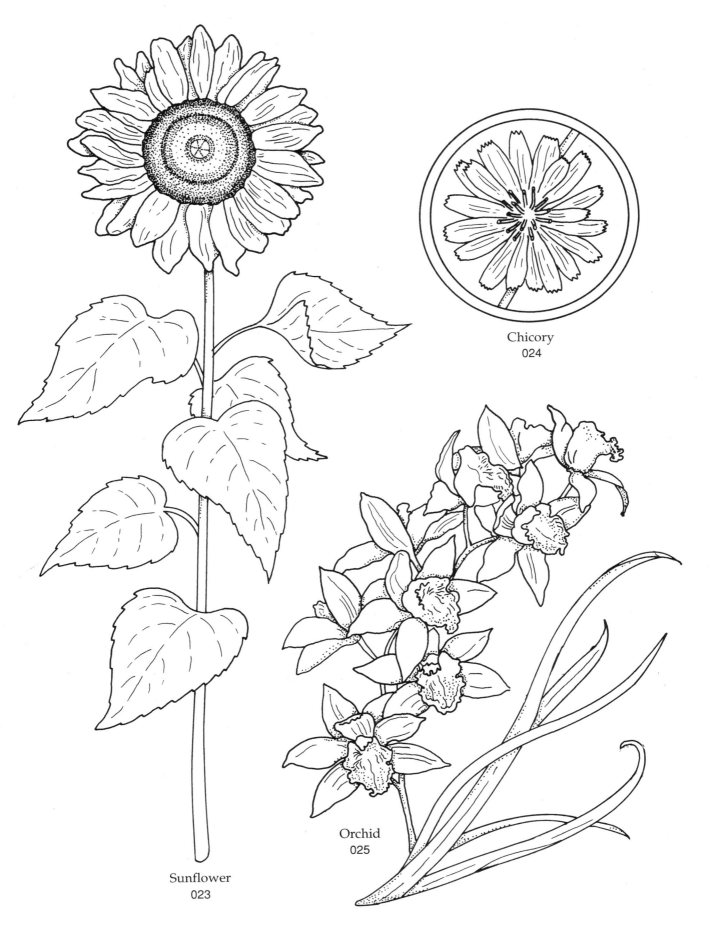

Chicory
024

Sunflower
023

Orchid
025

11

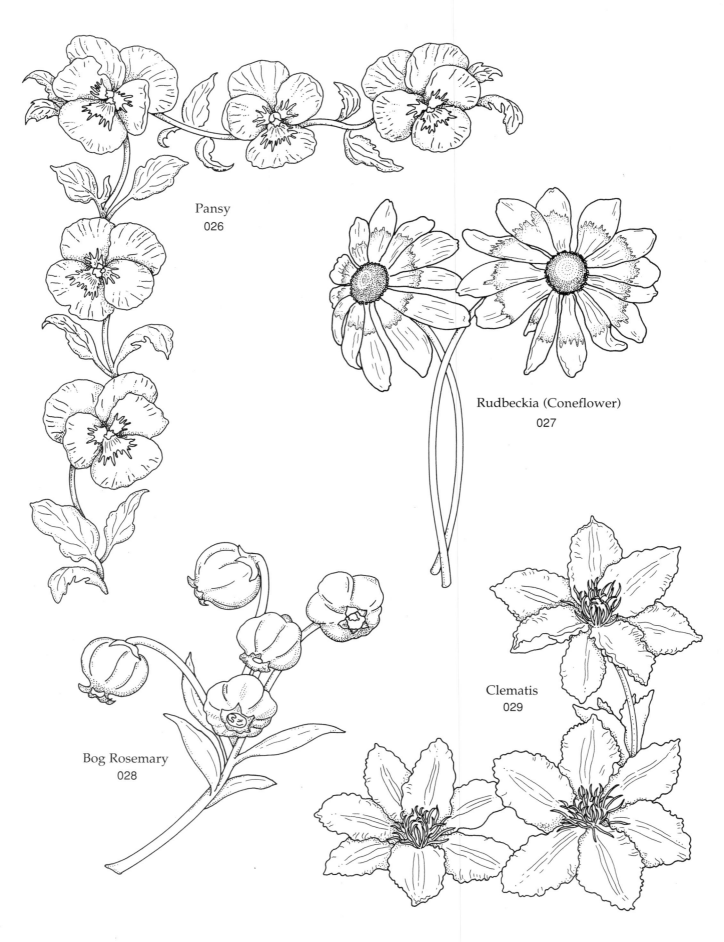

Pansy
026

Rudbeckia (Coneflower)
027

Clematis
029

Bog Rosemary
028

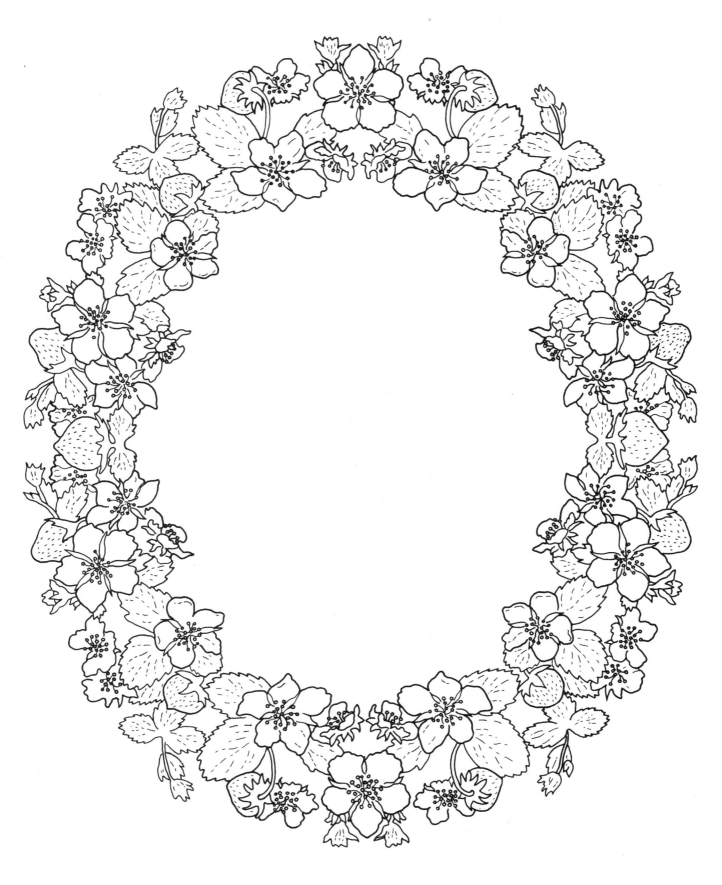

Wild Strawberry
030

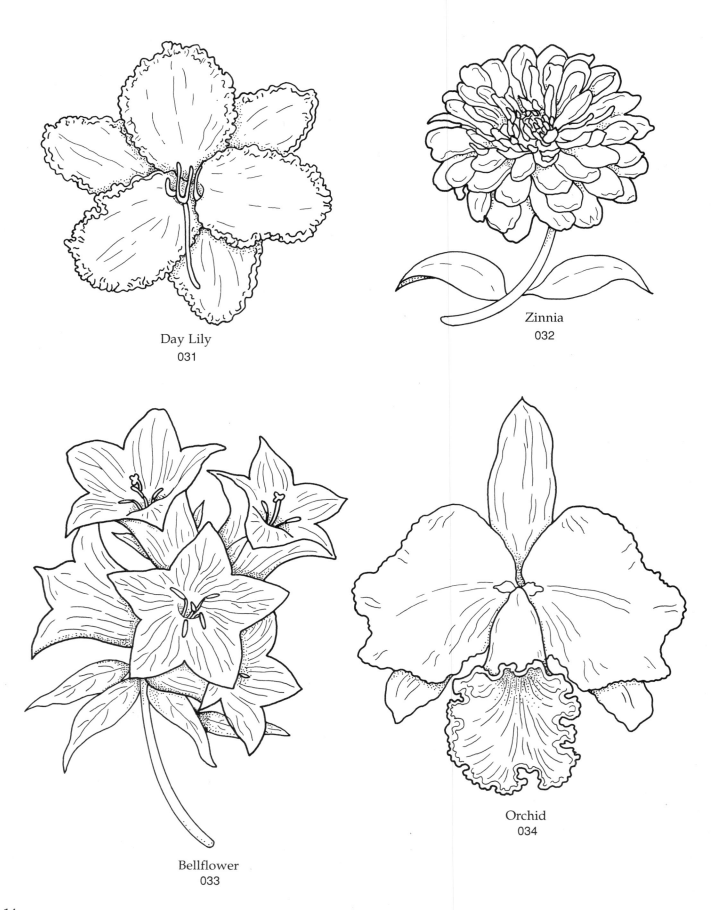

Day Lily
031

Zinnia
032

Bellflower
033

Orchid
034

14

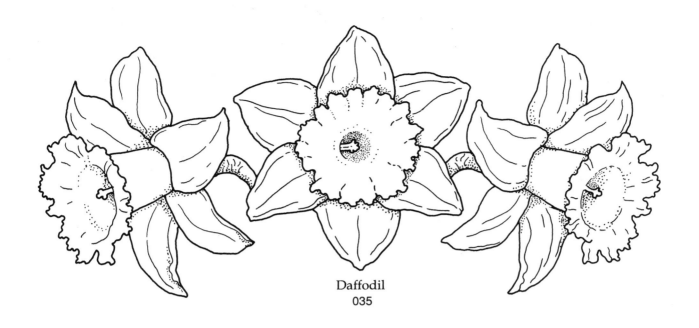

Daffodil
035

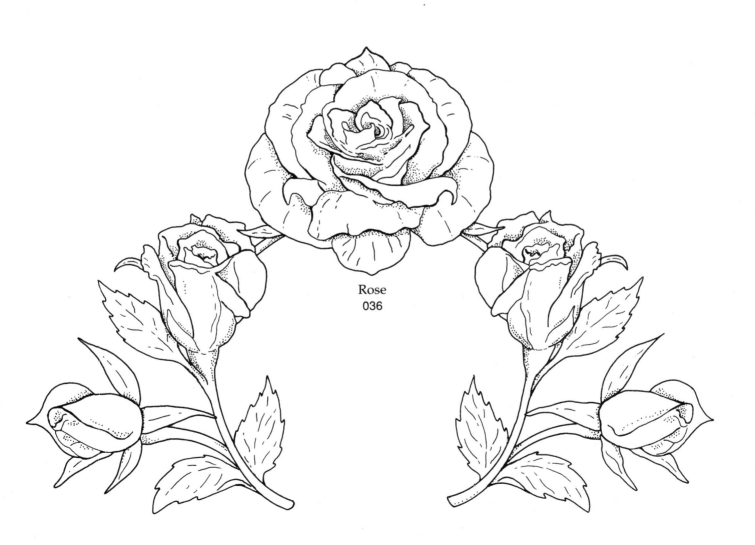

Rose
036

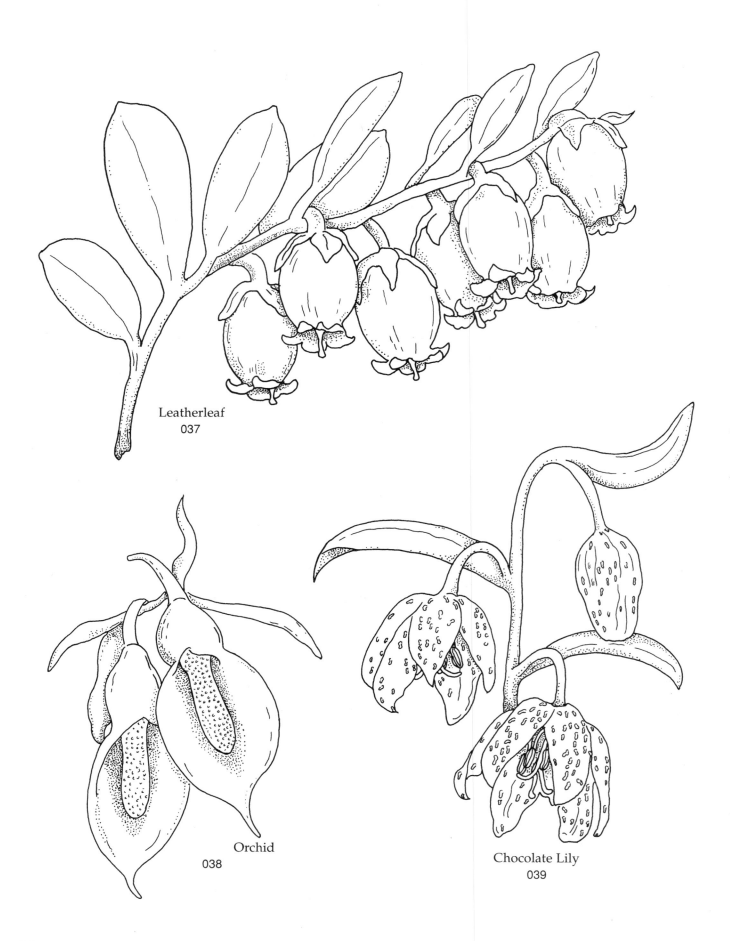

Leatherleaf
037

Orchid
038

Chocolate Lily
039

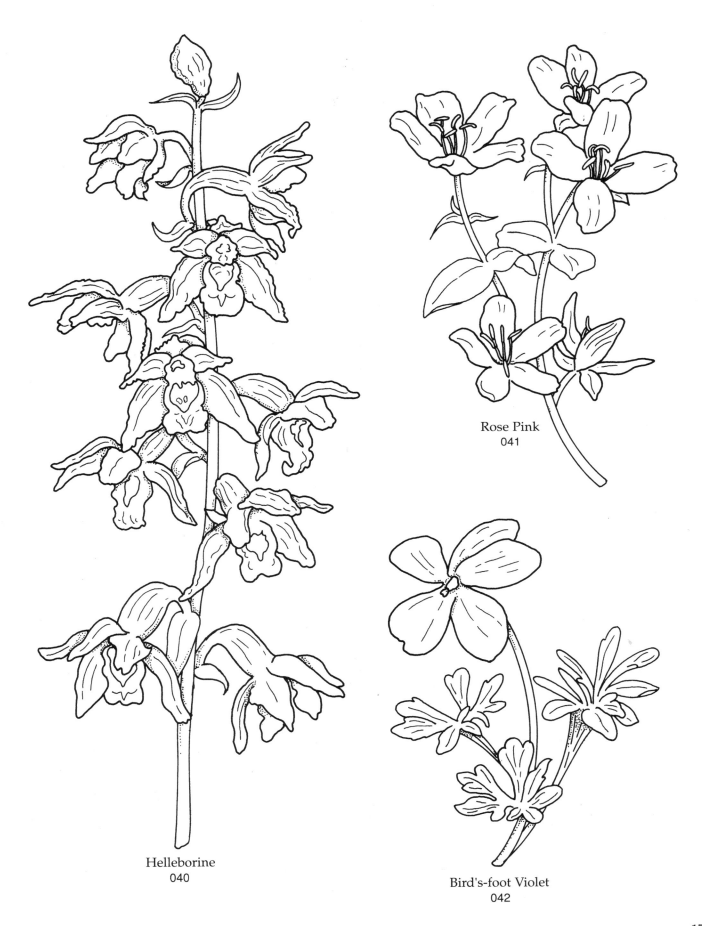

Helleborine
040

Rose Pink
041

Bird's-foot Violet
042

17

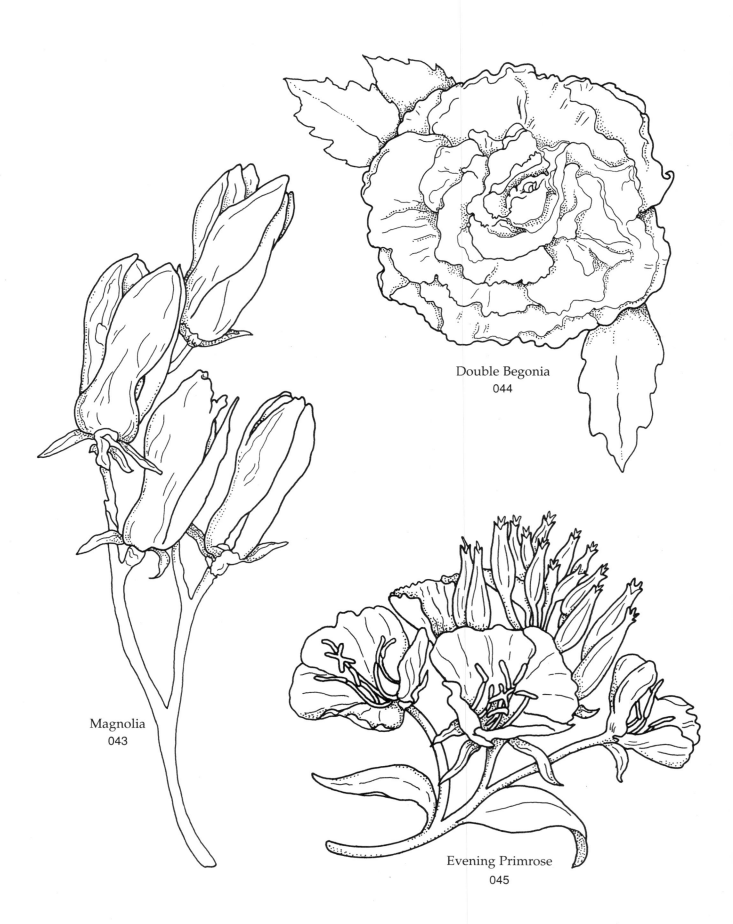

Magnolia
043

Double Begonia
044

Evening Primrose
045

18

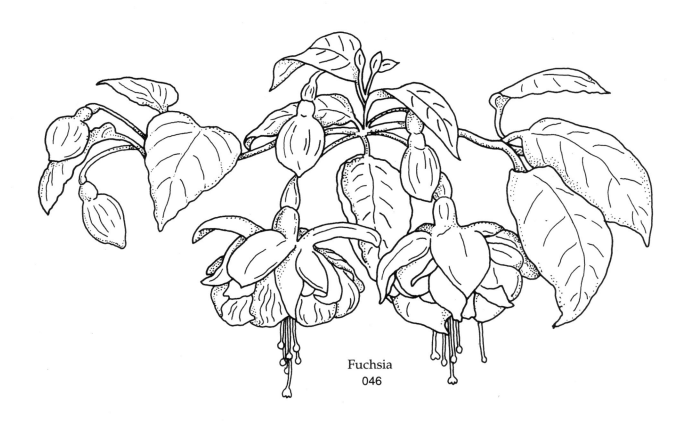

Fuchsia
046

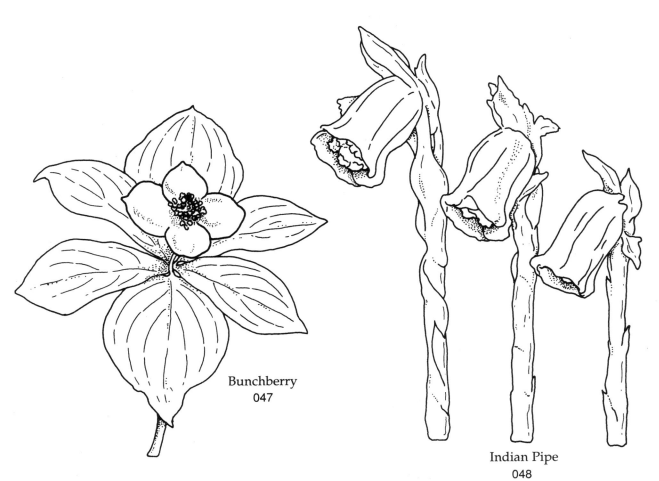

Bunchberry
047

Indian Pipe
048

19

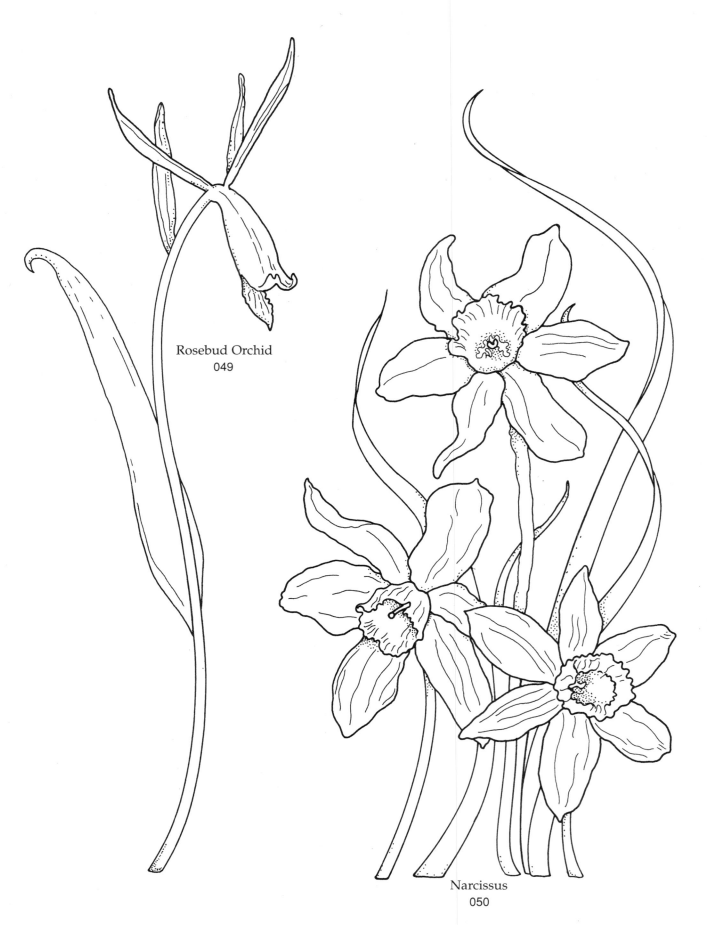

Rosebud Orchid
049

Narcissus
050

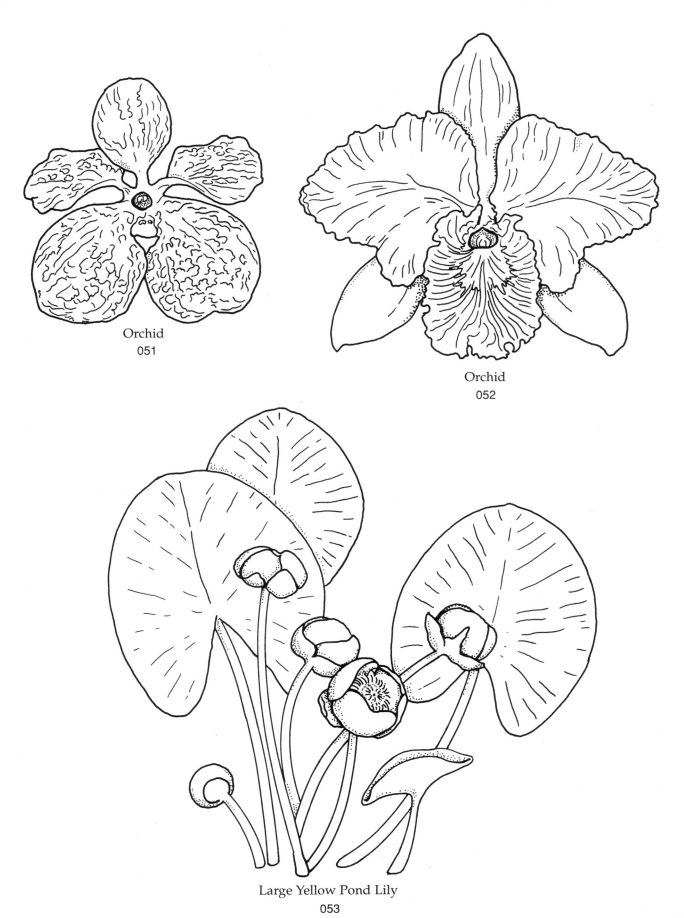

Orchid
051

Orchid
052

Large Yellow Pond Lily
053

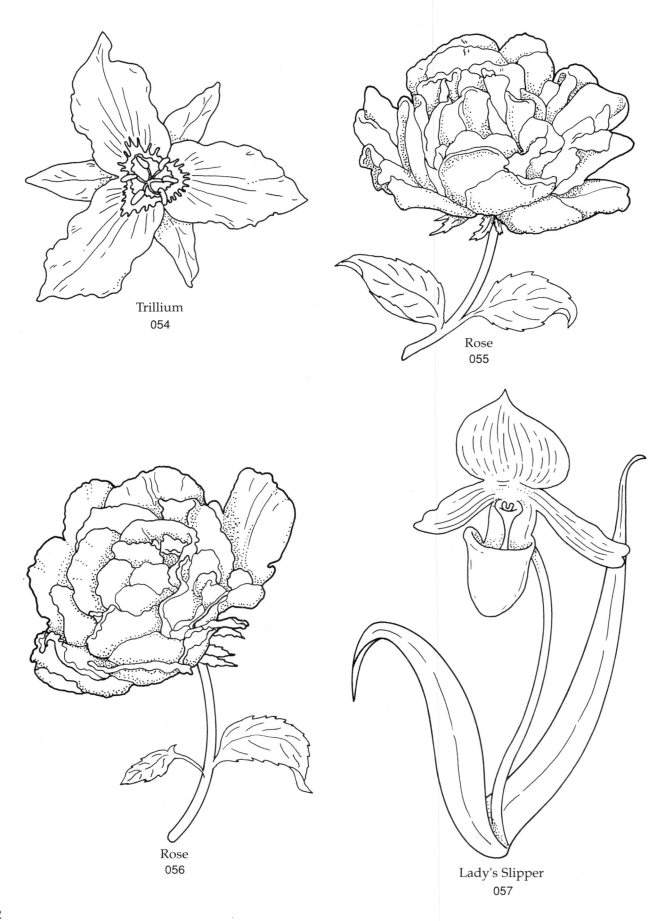

Trillium
054

Rose
055

Rose
056

Lady's Slipper
057

22

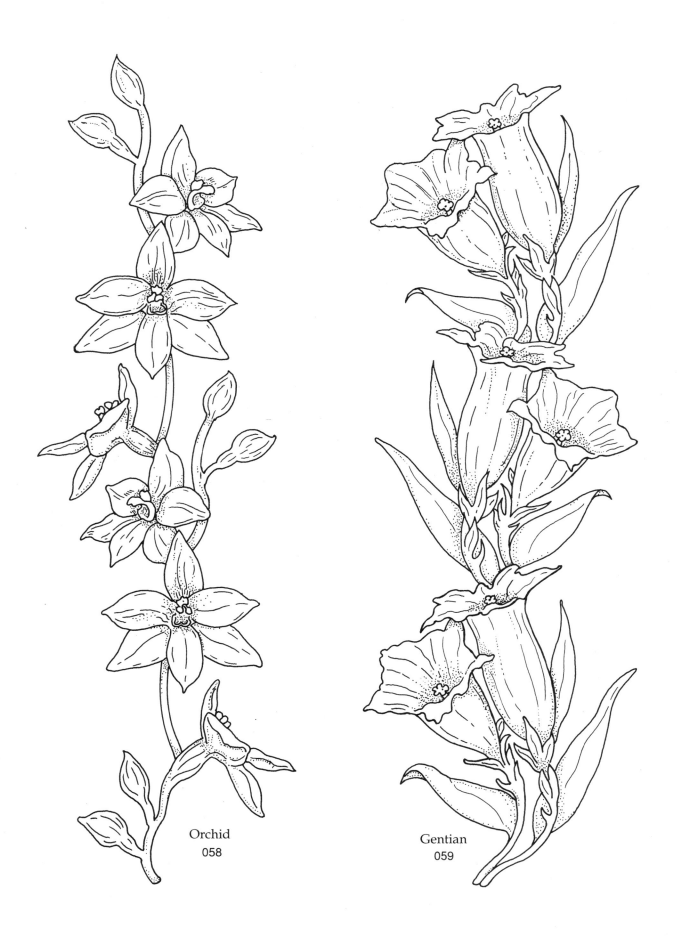

Orchid
058

Gentian
059

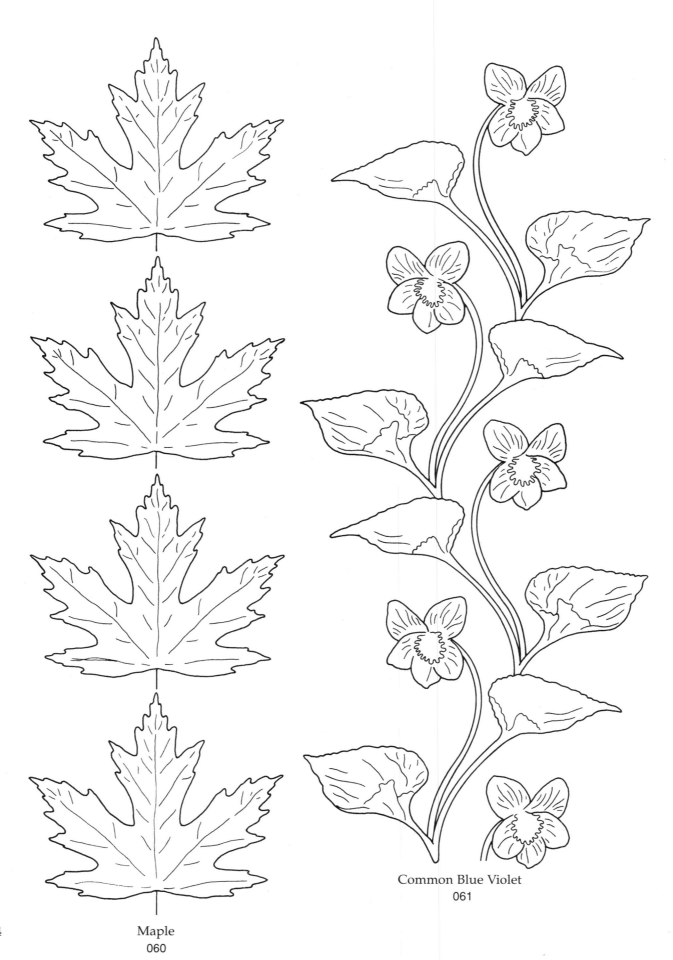

Common Blue Violet
061

Maple
060

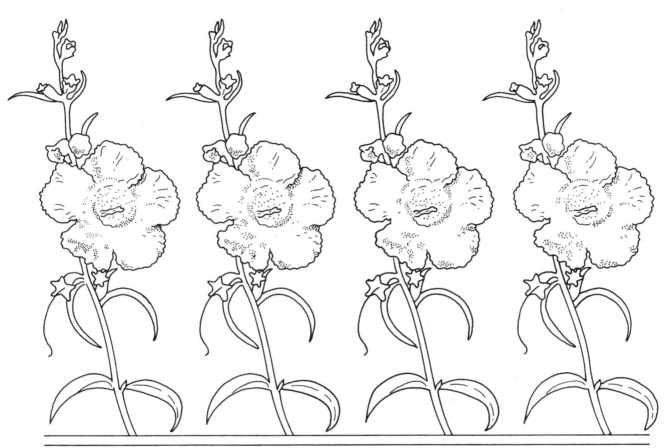

Purple Gerardia
062

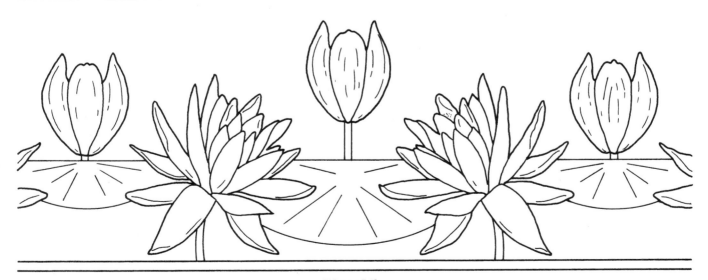

Water Lily
063

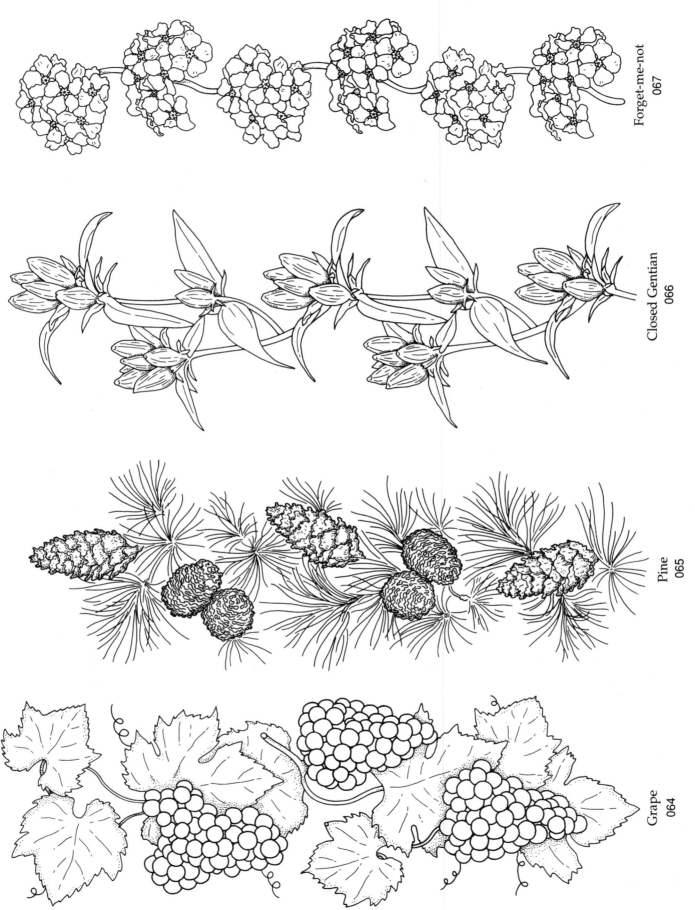

Forget-me-not
067

Closed Gentian
066

Pine
065

Grape
064

26

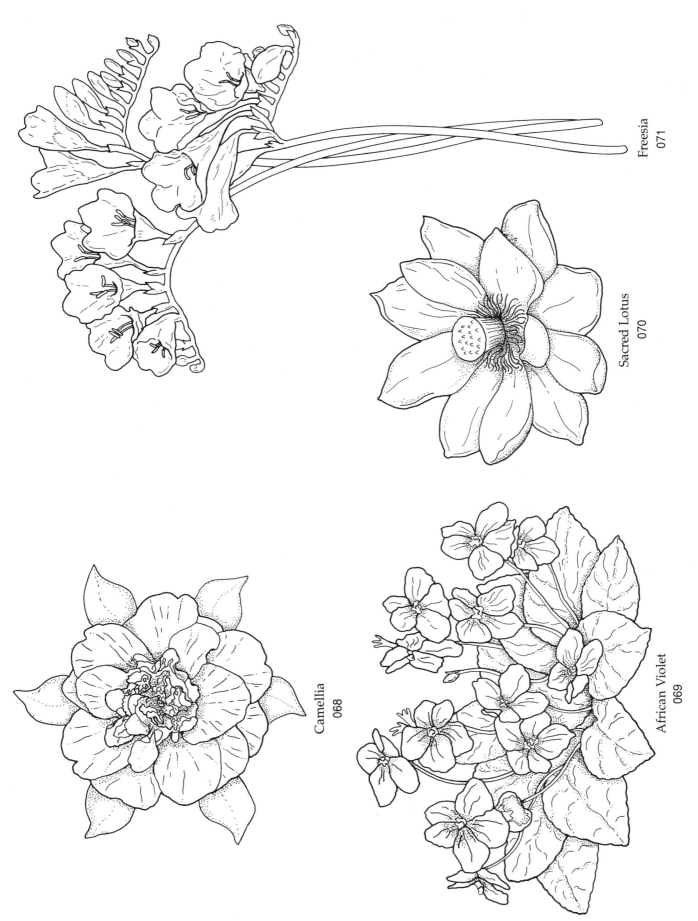

Freesia
071

Sacred Lotus
070

Camellia
068

African Violet
069

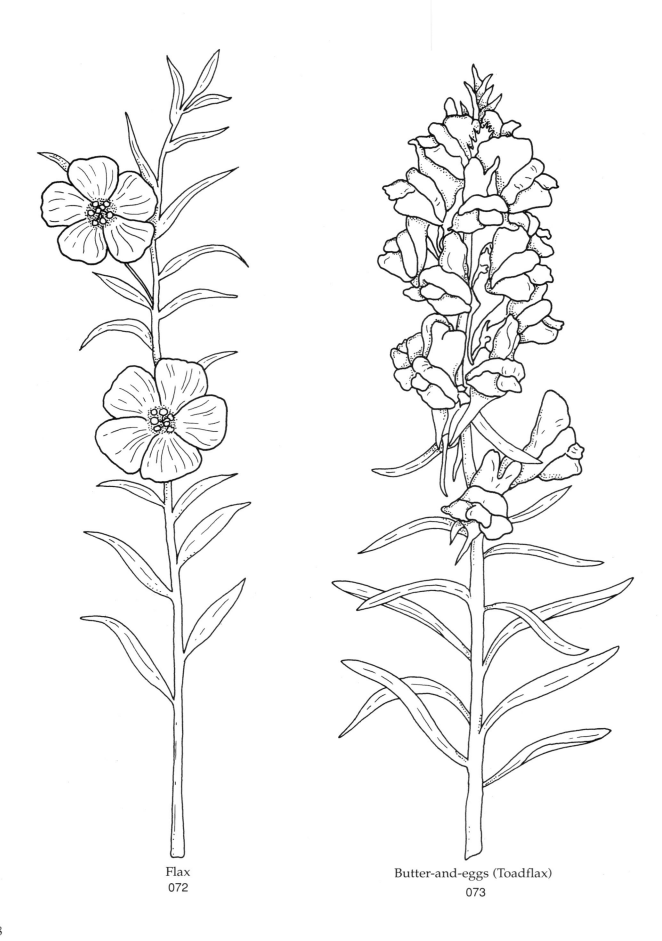

Flax
072

Butter-and-eggs (Toadflax)
073

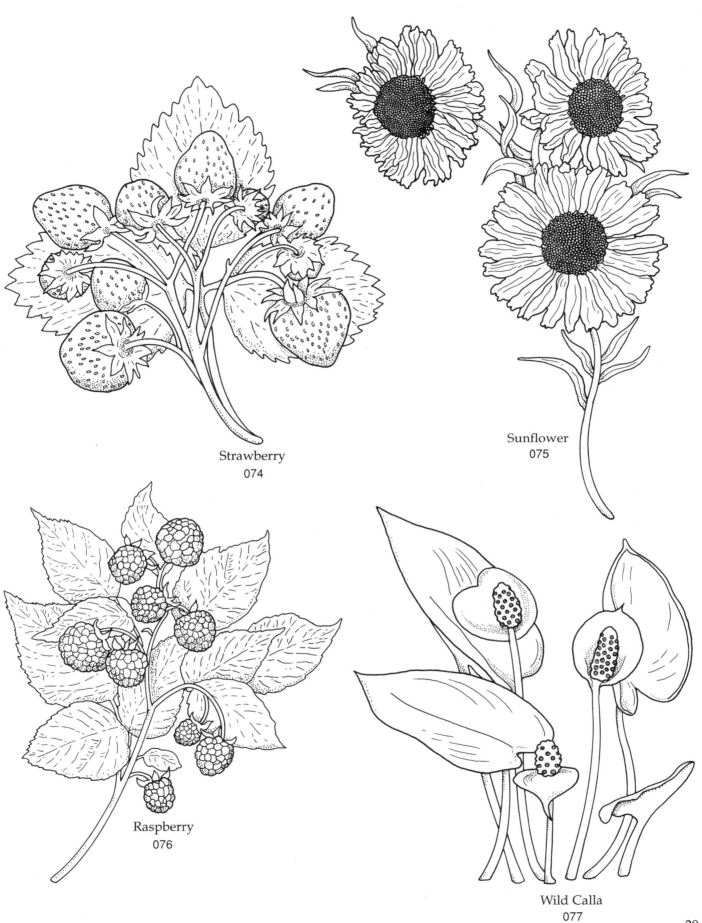

Strawberry
074

Sunflower
075

Raspberry
076

Wild Calla
077

29

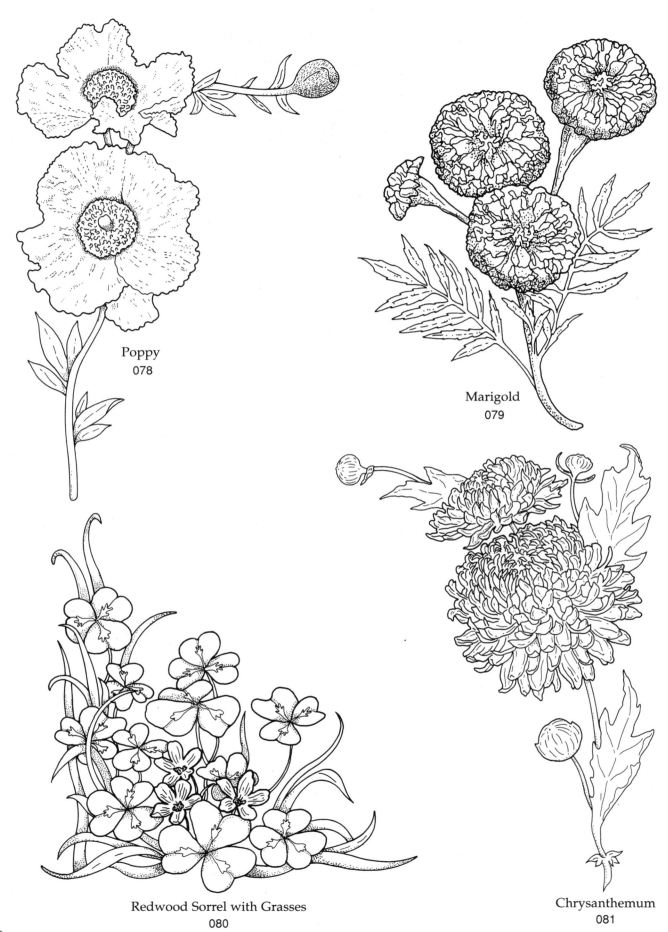

Poppy
078

Marigold
079

Redwood Sorrel with Grasses
080

Chrysanthemum
081

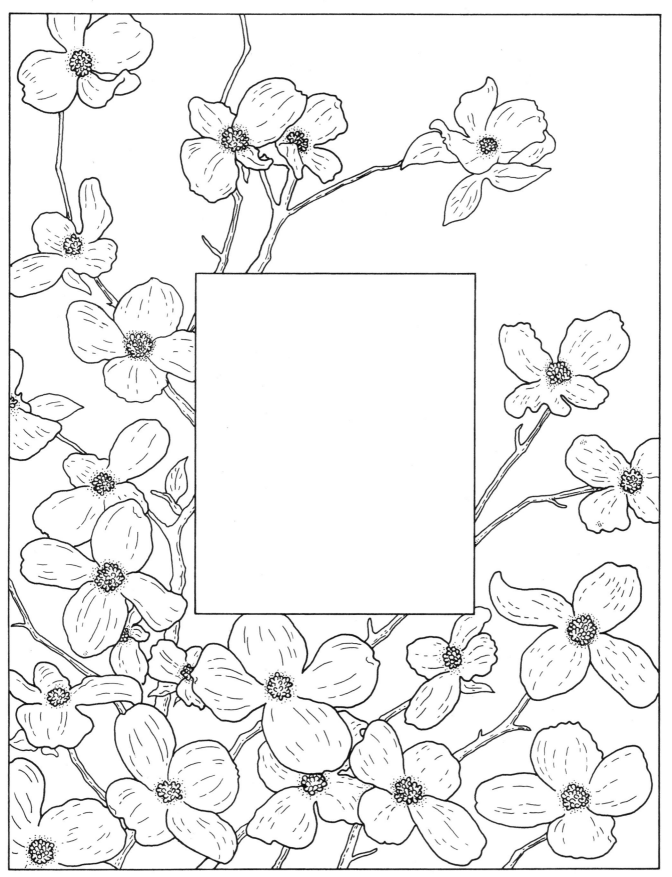

Dogwood
082

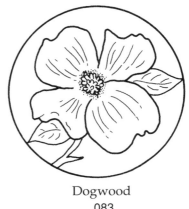

Dogwood
083

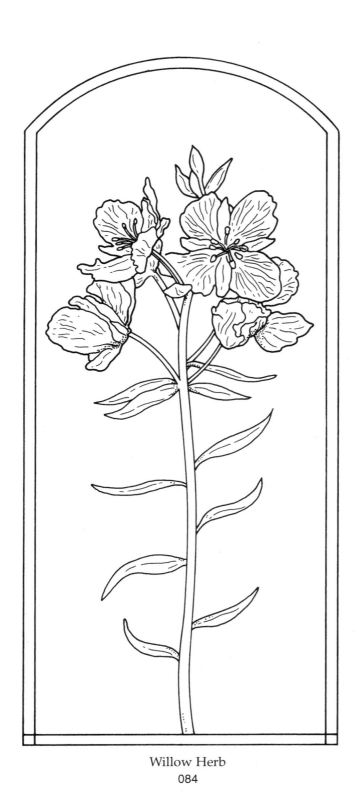

Willow Herb
084

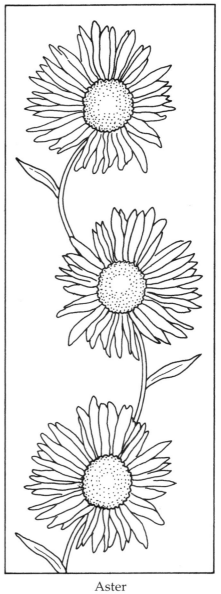

Aster
085

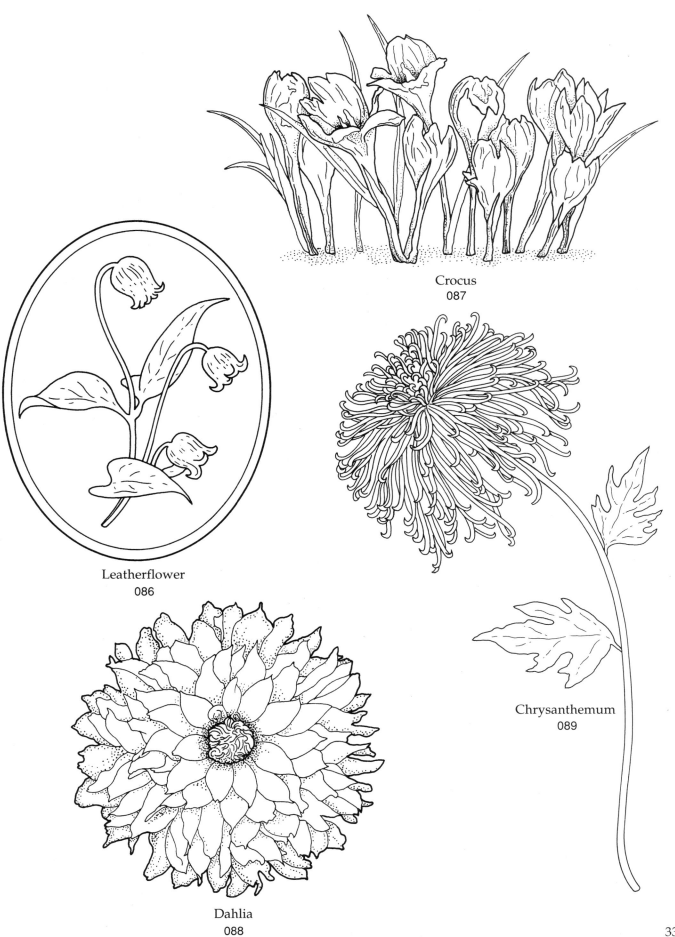

Crocus
087

Leatherflower
086

Chrysanthemum
089

Dahlia
088

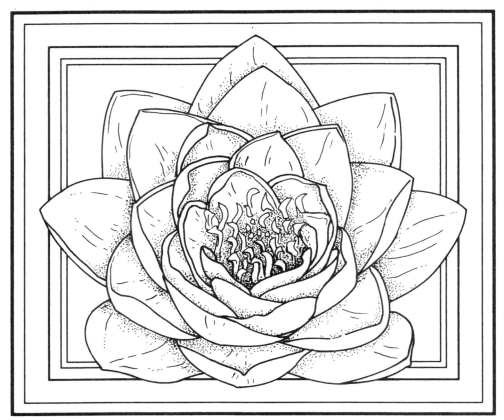

Water Lily
090

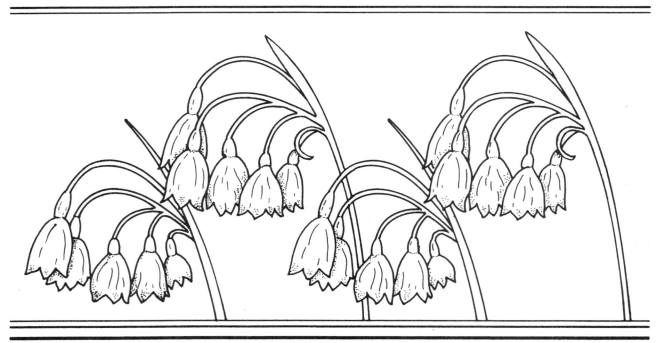

Leucojum
091

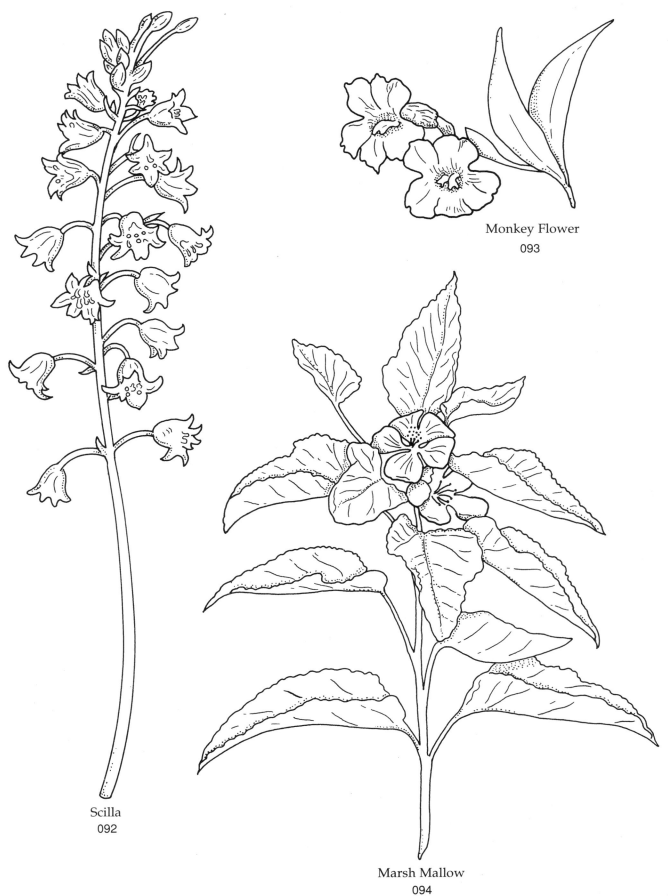

Monkey Flower
093

Scilla
092

Marsh Mallow
094

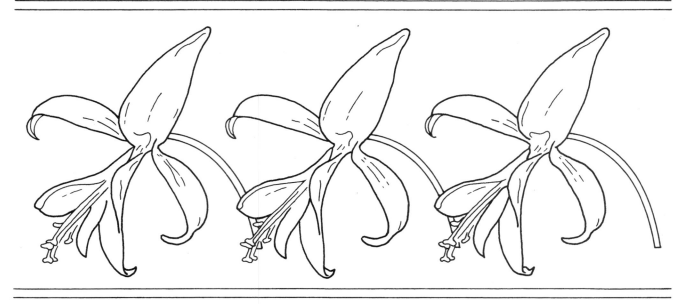

Aztec Lily
095

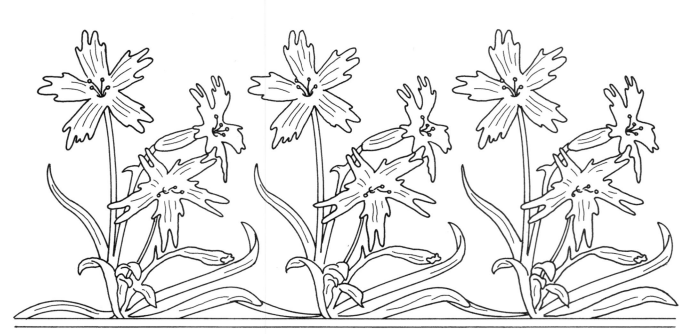

Fire Pink
096

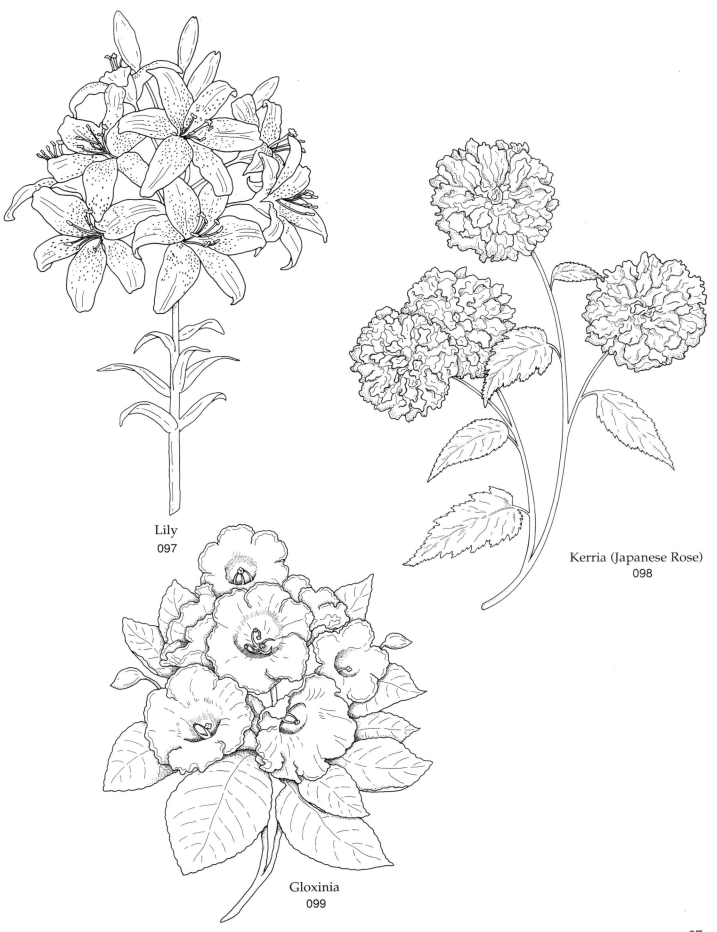

Lily
097

Kerria (Japanese Rose)
098

Gloxinia
099

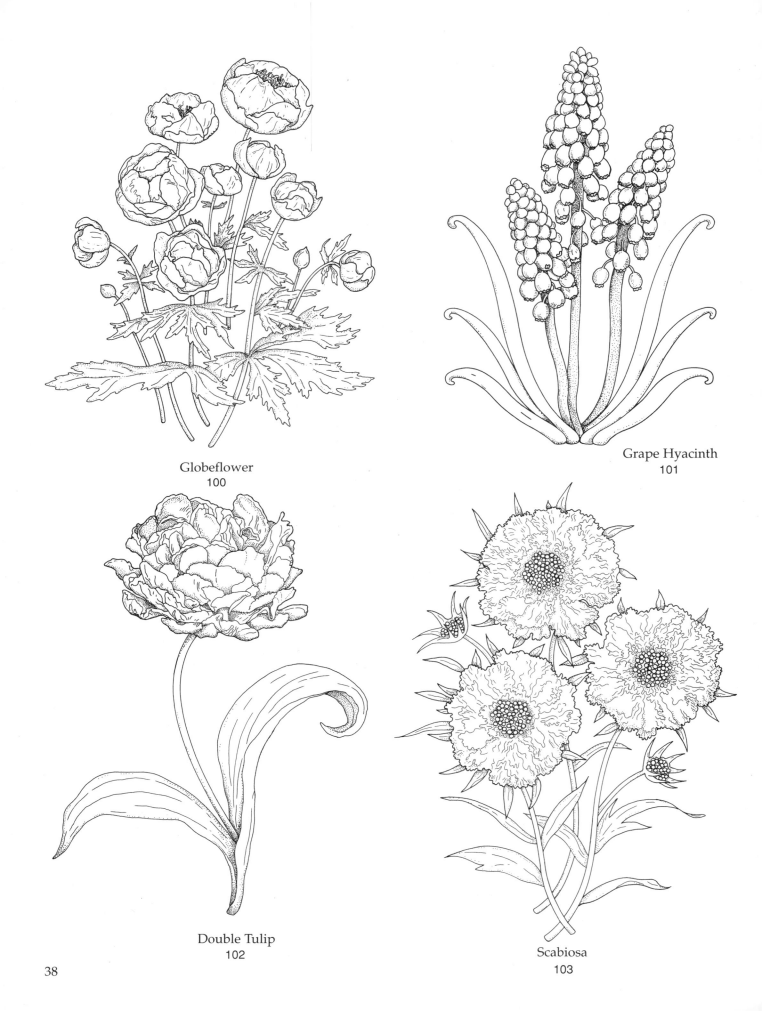

Globeflower
100

Grape Hyacinth
101

Double Tulip
102

Scabiosa
103

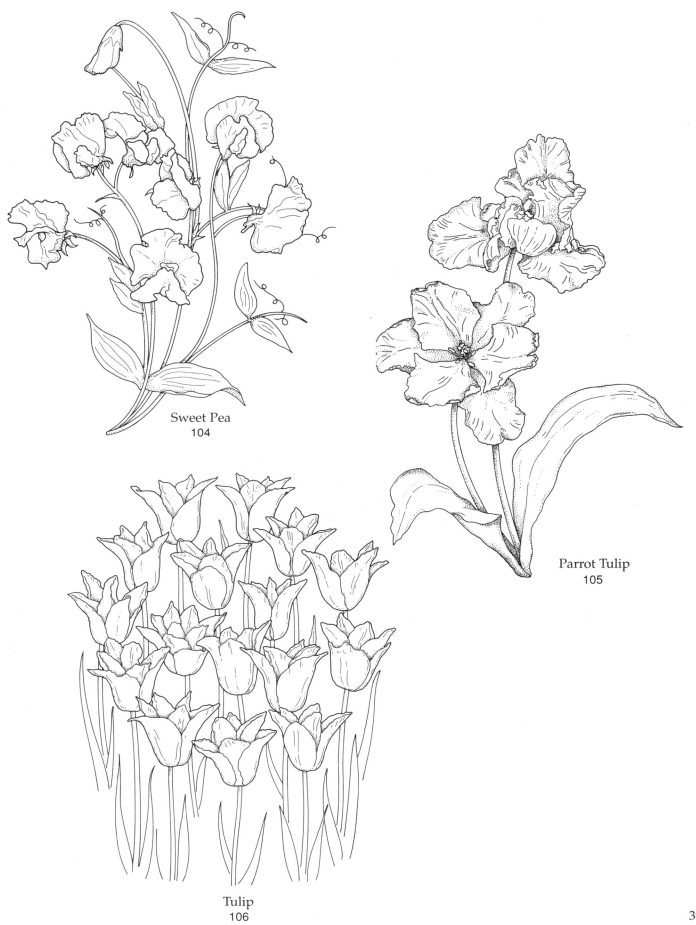

Sweet Pea
104

Parrot Tulip
105

Tulip
106

39

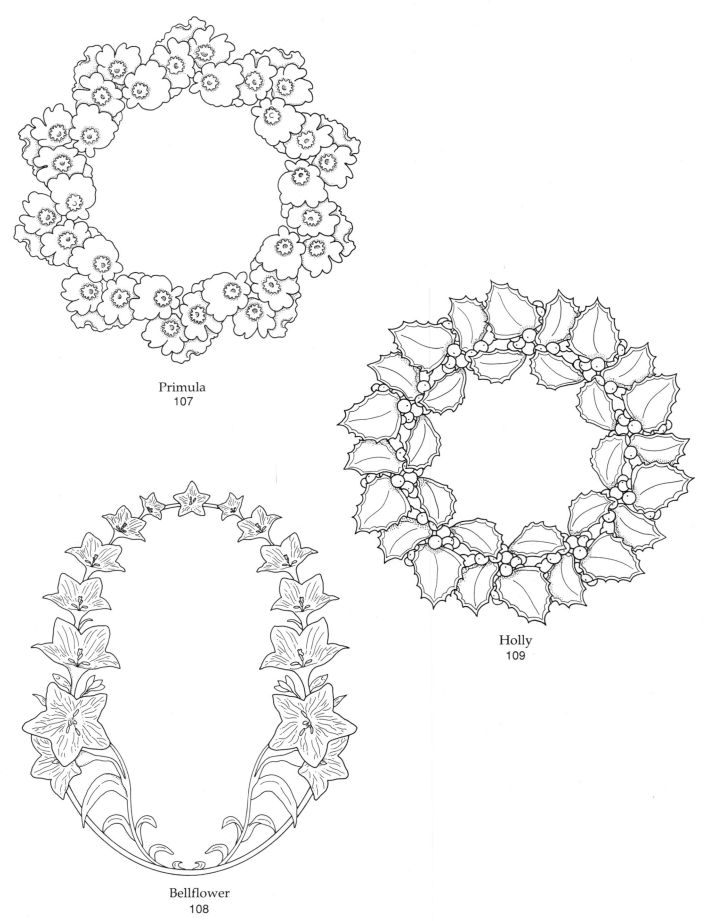

Primula
107

Holly
109

Bellflower
108

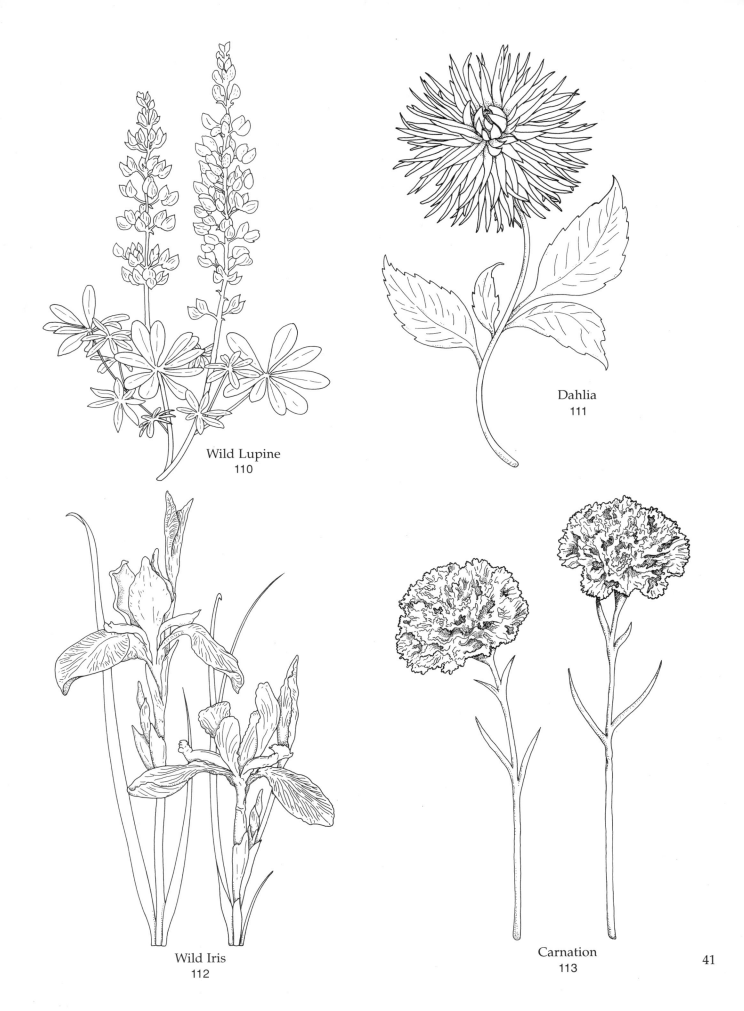

Wild Lupine
110

Dahlia
111

Wild Iris
112

Carnation
113

41

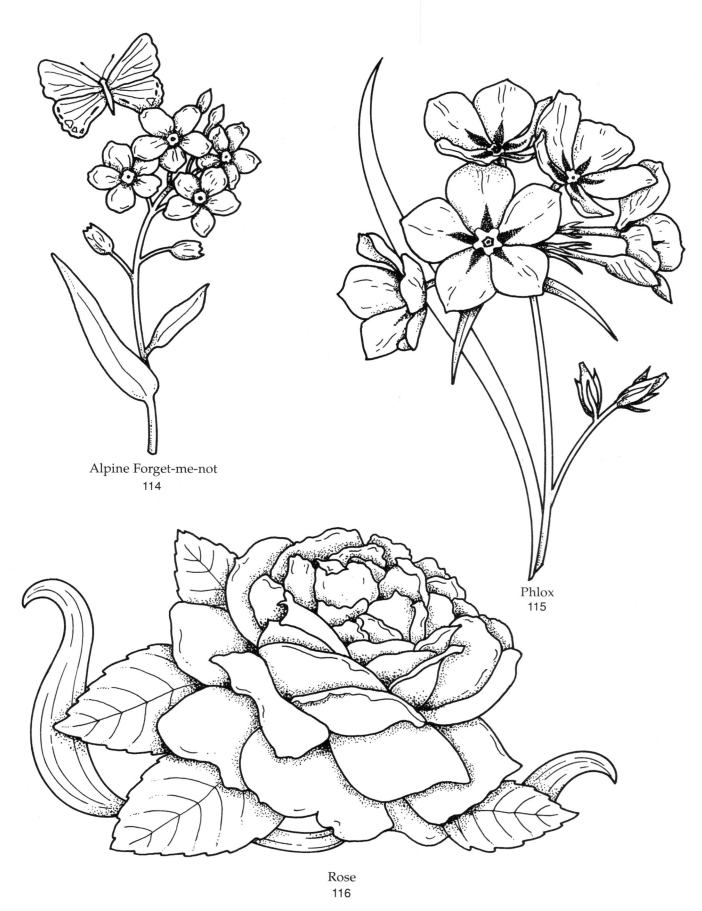

Alpine Forget-me-not
114

Phlox
115

Rose
116

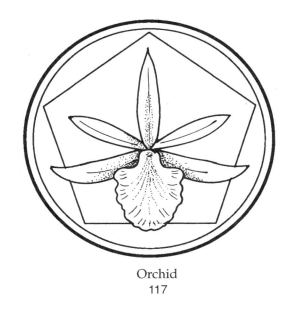

Orchid
117

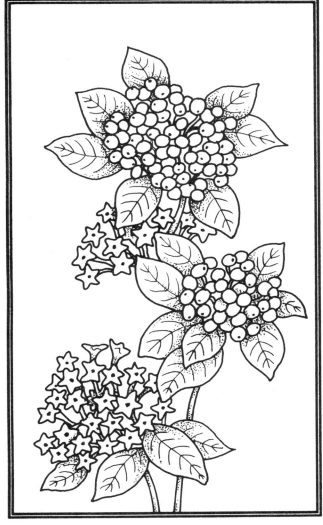

Viburnum
118

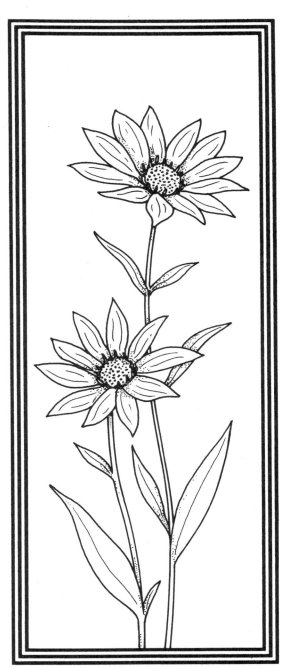

Wild Sunflower
119

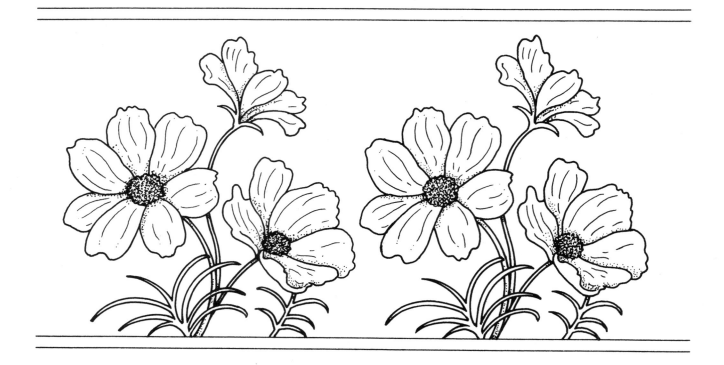

Cosmos
120

Yellow Wood Sorrel
121

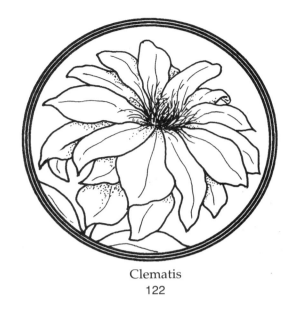

Clematis
122

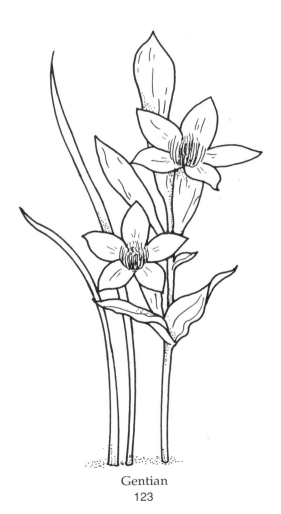

Gentian
123

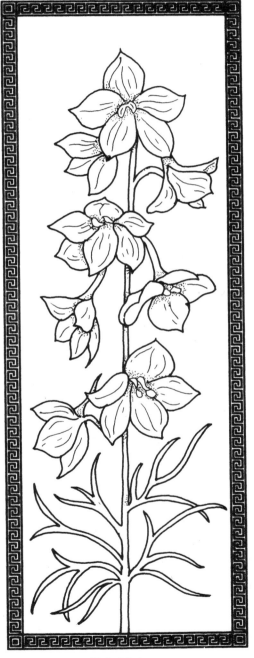

Delphinium
124

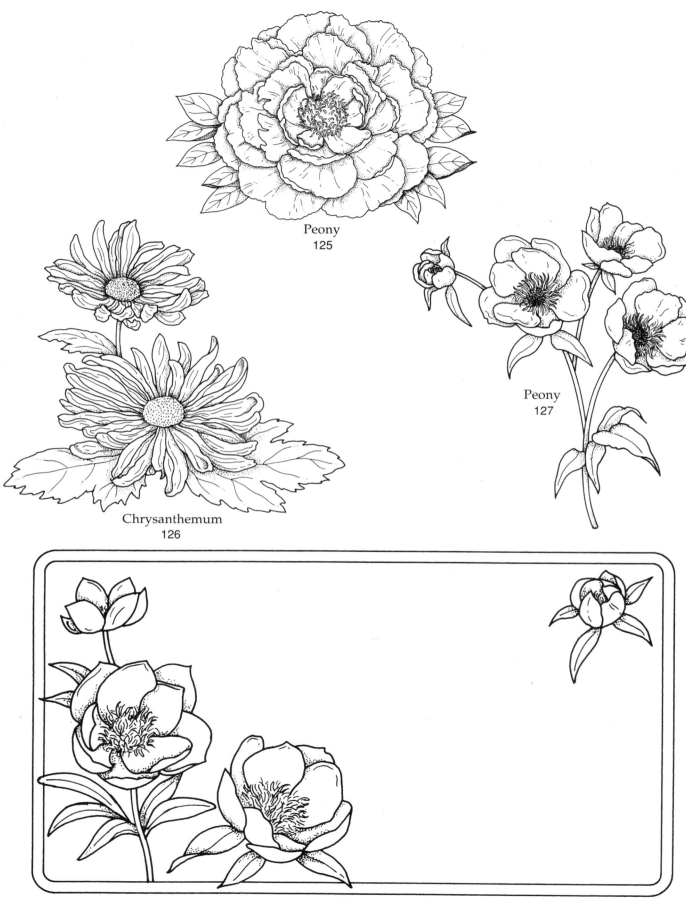

Peony
125

Chrysanthemum
126

Peony
127

Peony
128

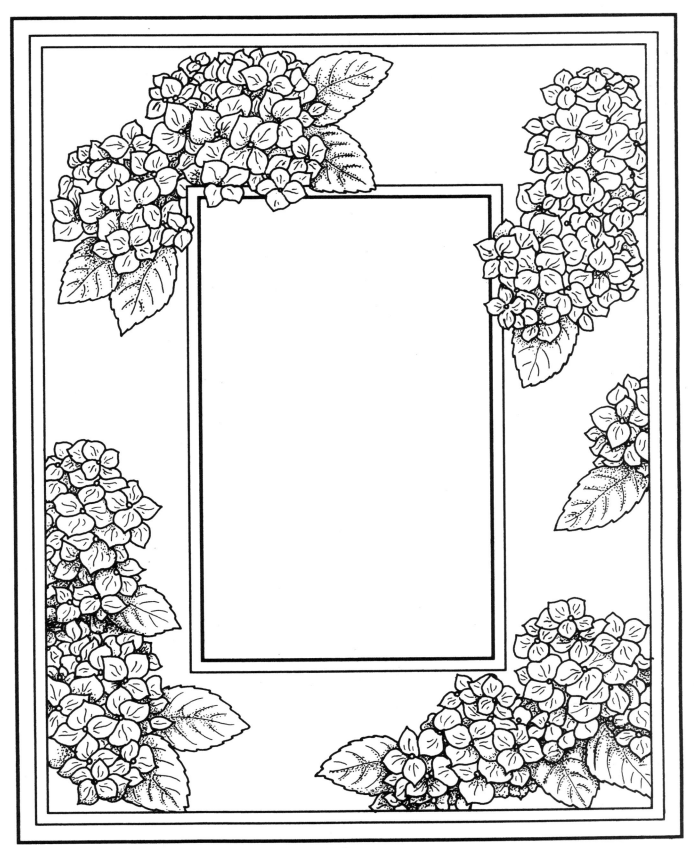

Hydrangea
129

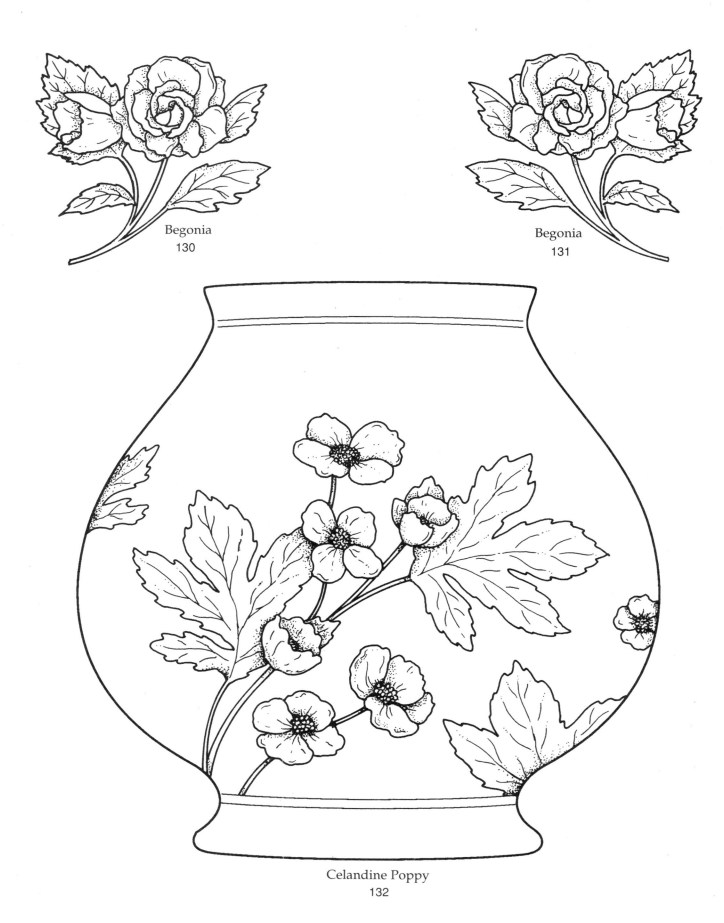

Begonia
130

Begonia
131

Celandine Poppy
132

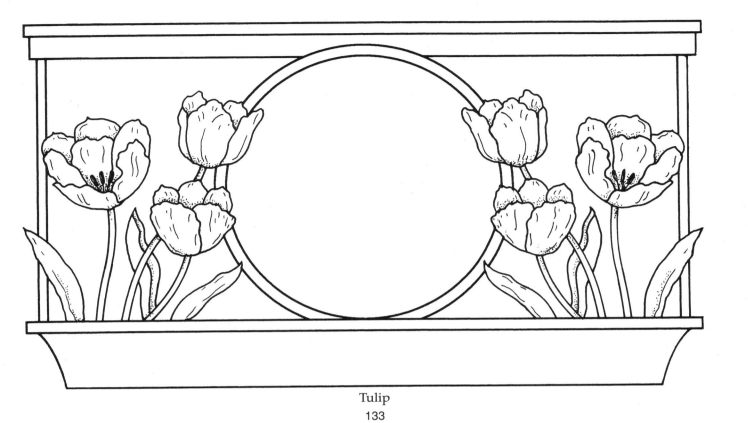

Tulip
133

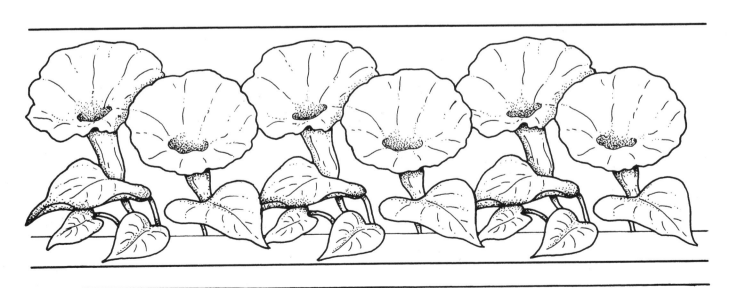

Morning Glory
134

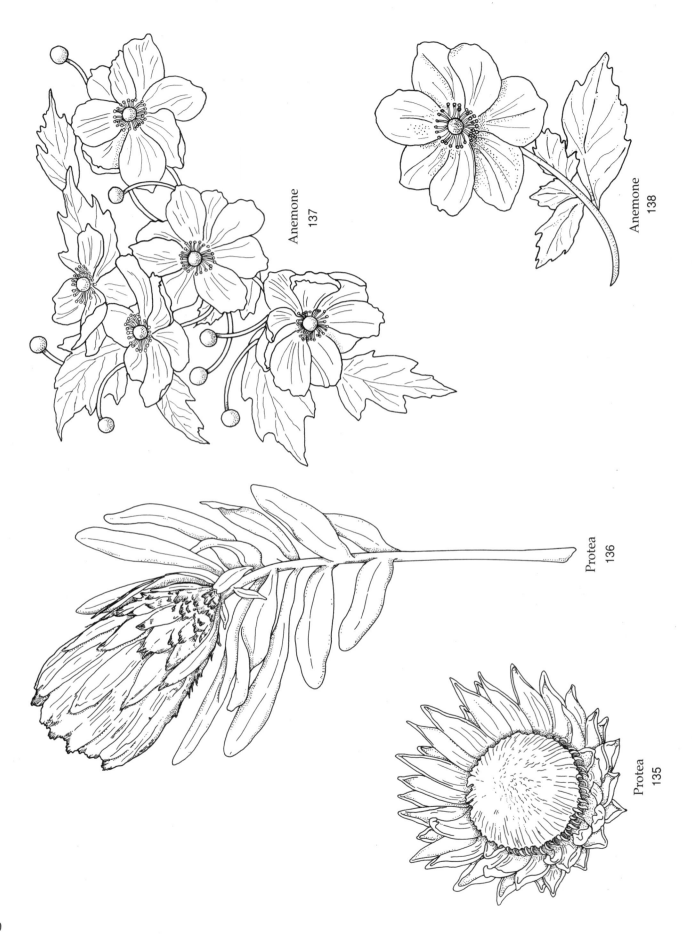

Anemone
137

Anemone
138

Protea
136

Protea
135

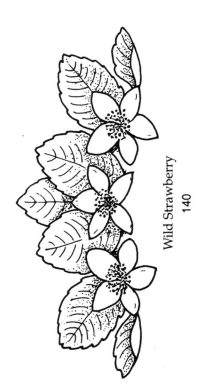

Wild Strawberry
140

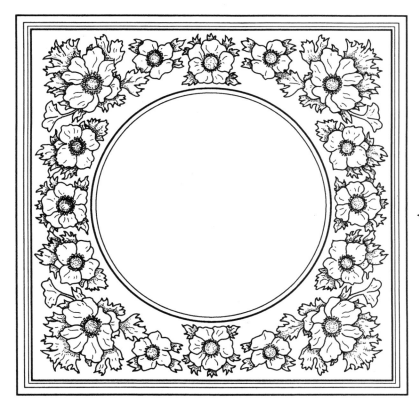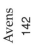

Avens
142

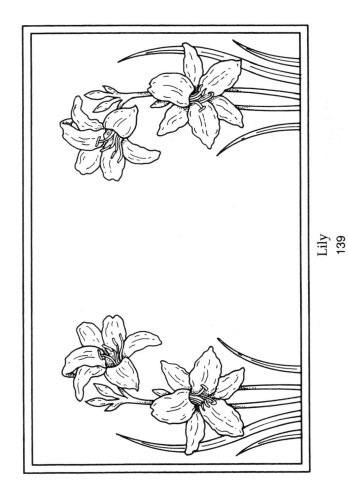

Lily
139

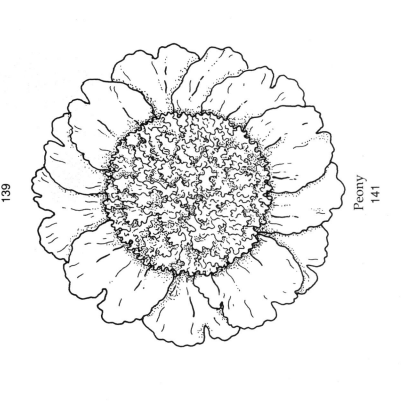

Peony
141

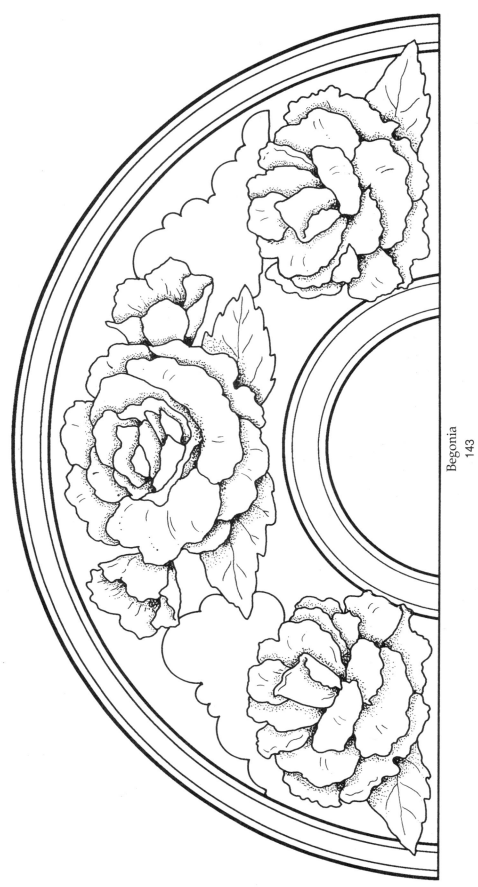

Begonia
143

Campanula
144

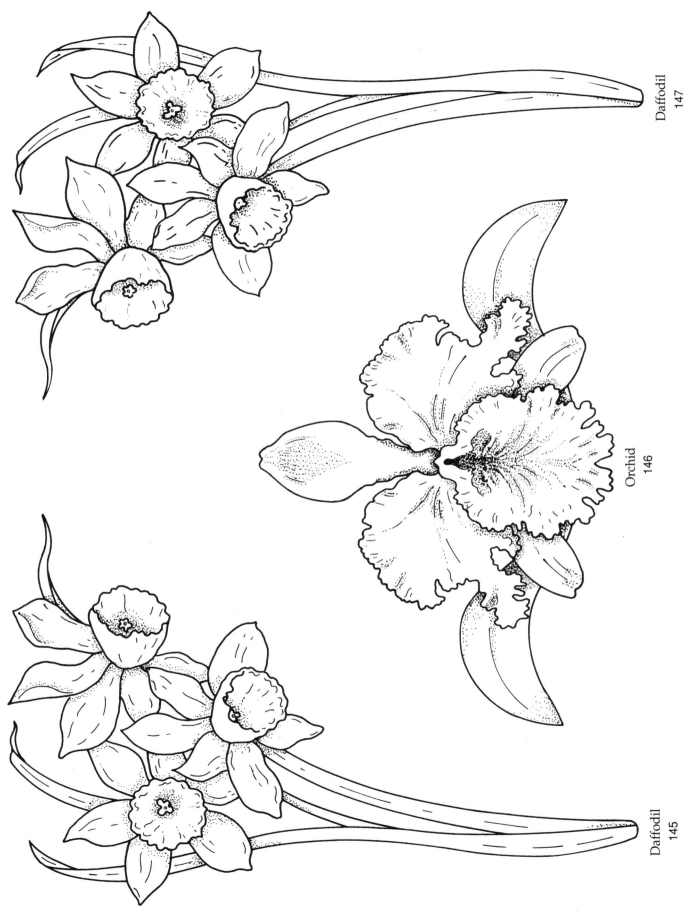

Daffodil
147

Orchid
146

Daffodil
145

53

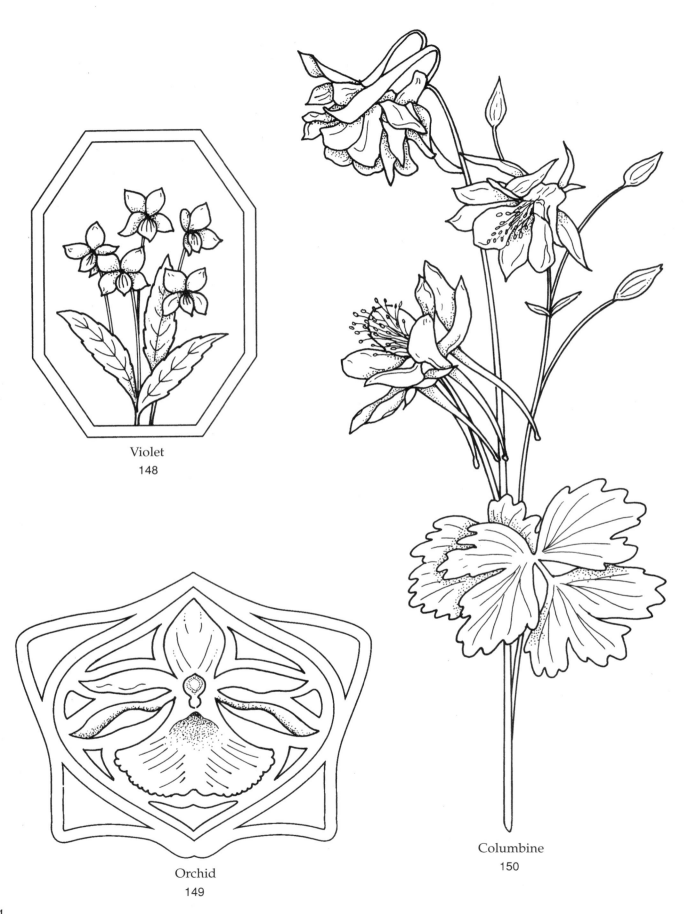

Violet
148

Orchid
149

Columbine
150

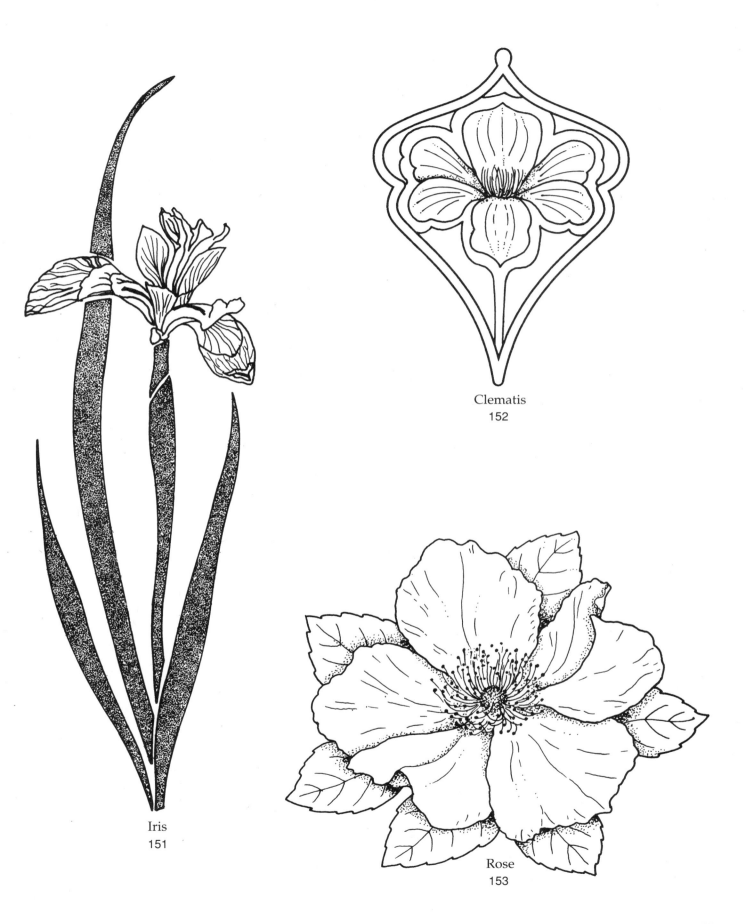

Clematis
152

Iris
151

Rose
153

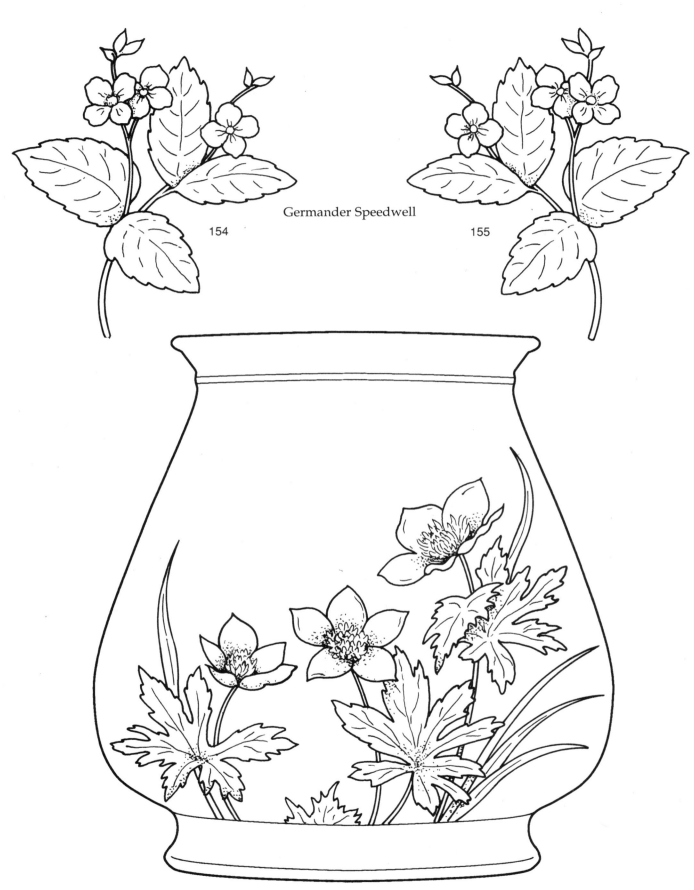

Germander Speedwell

154 155

Globeflower

156

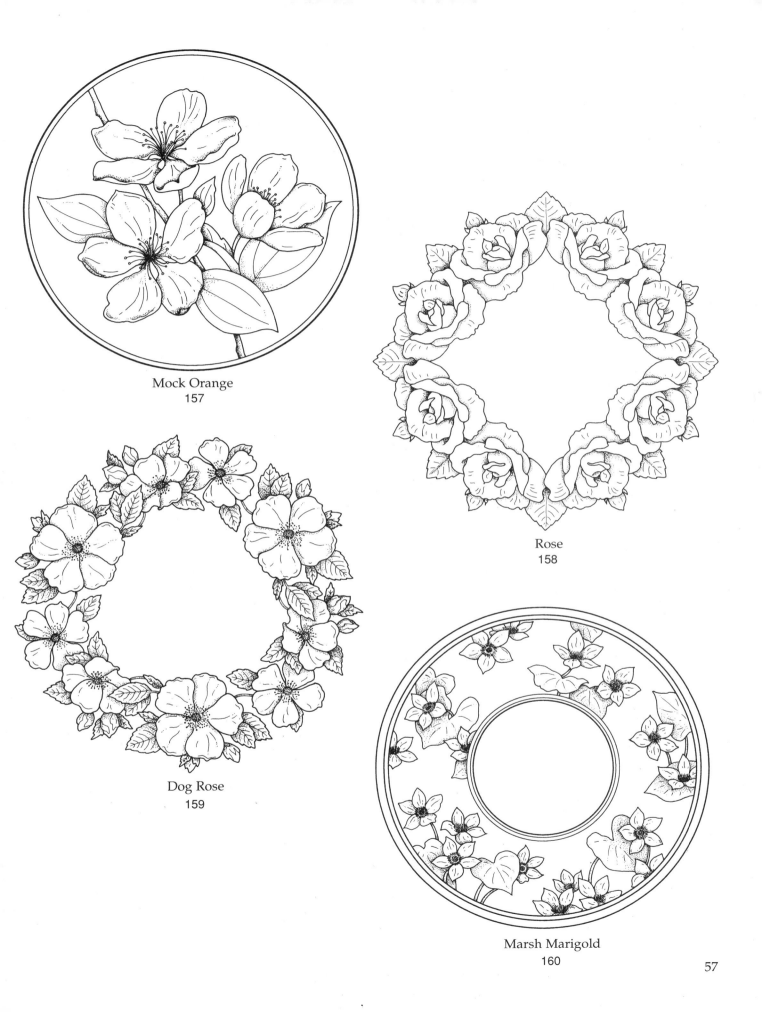

Mock Orange
157

Rose
158

Dog Rose
159

Marsh Marigold
160

57

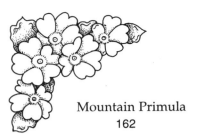

Mountain Primula
162

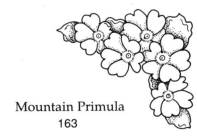

Mountain Primula
163

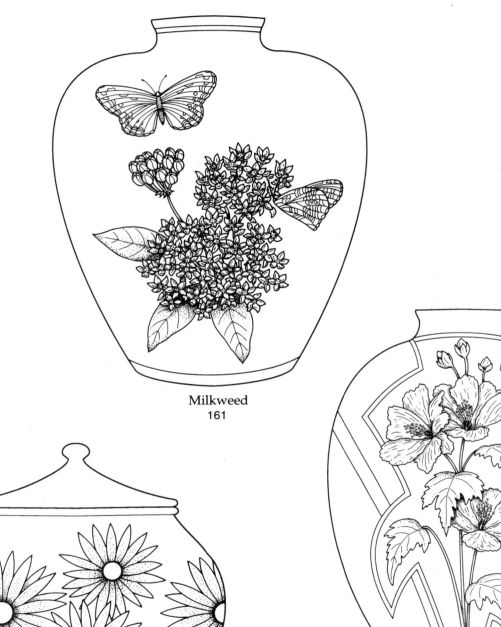

Milkweed
161

Daisy
164

Mallow
165

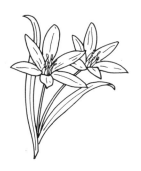

Star of Bethlehem
167

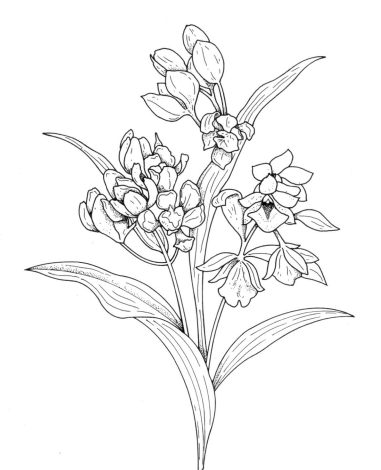

Orchid
166

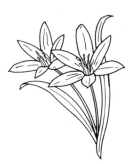

Star of Bethlehem
168

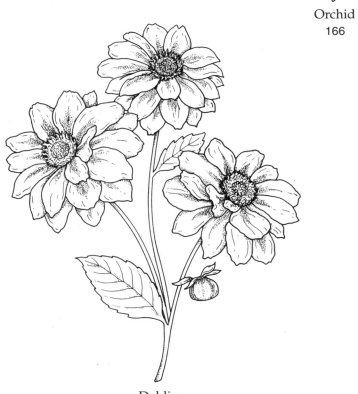

Dahlia
169

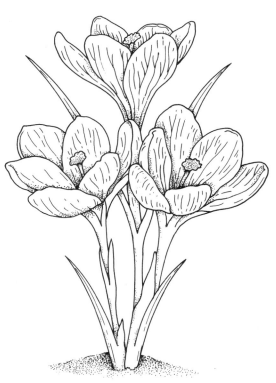

Crocus
170

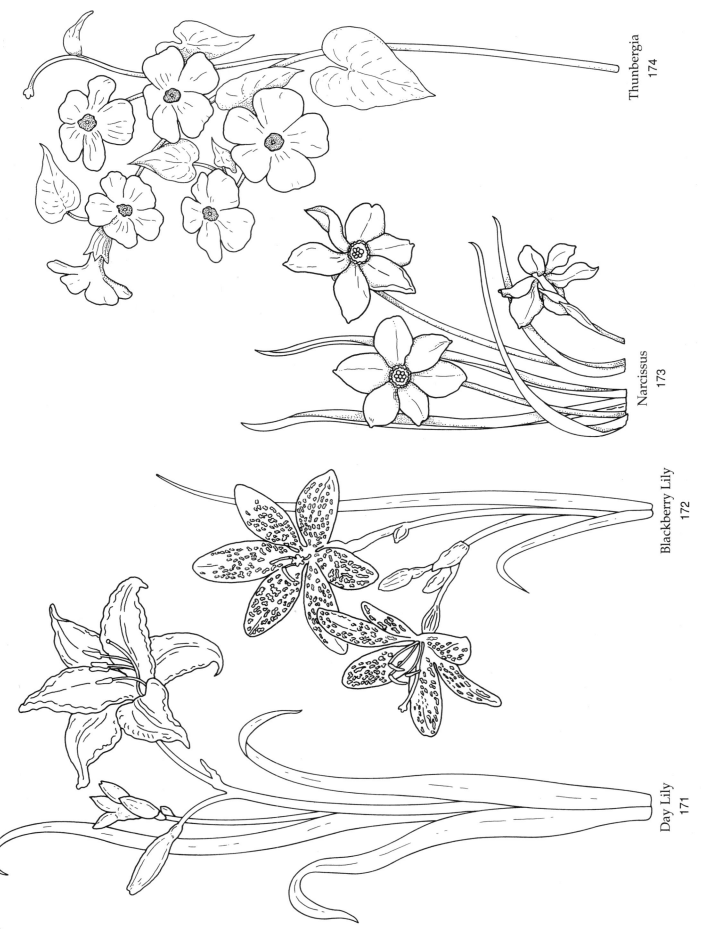

Thunbergia
174

Narcissus
173

Blackberry Lily
172

Day Lily
171

INDEX